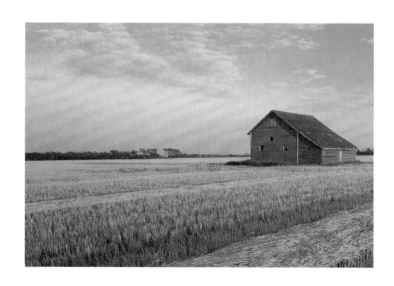

MANITOBA

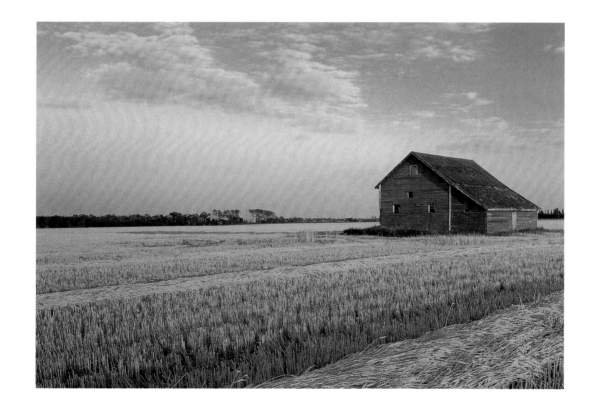

WHITECAP BOOKS

Text by Tanya Lloyd
Edited by Elaine Jones
Photo editing by Tanya Lloyd
Proofread by Lisa Collins
Cover and interior design by Steve Penner
Desktop publishing by Susan Greenshields
Printed and bound in Canada

National Library of Canada Cataloguing in Publication Data

Lloyd, Tanya, 1973–

 Manitoba

 ISBN 1-55285-077-3

 1. Manitoba—Pictorial works. I. Title.
FC3362.L56 2000 971.27'03'0222 C00-910059-8
F1062.8.L56 2000
The publisher acknowledges the support of the Canada Council and the Cultural
Services Branch of the Government of British Columbia in making this publication
possible. We acknowledge the financial support of the Government of Canada through
the Book Publishing Industry Development Program for our publishing activities.

For more information on the Canada Series and other Whitecap Books
titles, please visit our web site at www.whitecap.ca.

A vast expanse of wheat fields and canola crops, herds of bison, and rolling grasslands stretching to the horizon. As one of Canada's prairie provinces, Manitoba most often evokes these rural images. And in one region of the province, the descriptions ring true. A triangle of fertile land between Saskatchewan, the United States, and Lake Winnipeg produces $2.7 billion each year in agricultural products—more than 40 percent of that in wheat alone. Rich fields yield abundant canola and flaxseed, and Manitoba leads the country in the production of sunflower seeds, buckwheat, and field peas.

Yet this is only one region of a vast and diverse land. More than half of the Keystone Province—named for its shape and its place in the centre of the country—is part of the Canadian Shield, the rugged horseshoe of rocky outcroppings scoured by the last ice age and dating to the Precambrian era. Dense forests rich with wildlife carpet parts of the shield, while thousands of streams and rivers course over the rock in other areas.

All of these water systems flow towards the north, emptying into the vast sea that is Hudson Bay. Around these icy shores, where enormous icebergs float even in midsummer, lies the tundra—a frigid and seemingly barren land stretching in every direction. But the earth here is far from empty. Uniquely adapted to these harsh climes, more than 400 plant species grow near Churchill. A startling array of birds—more than 200 species—and small mammals make their homes in the shrubs and lichens. And each fall, these are joined by mammoth polar bears, that gather at the shore of the bay to await the pack ice and access to their winter hunting grounds.

Those who have never visited Manitoba might picture flat roads leading through grids of cropland, following straight lines towards the horizon. But in fact, the roads here take many unexpected turns, revealing an astounding diversity of secluded lakes and churning rivers, rugged coastlines, and wilderness areas waiting to be discovered.

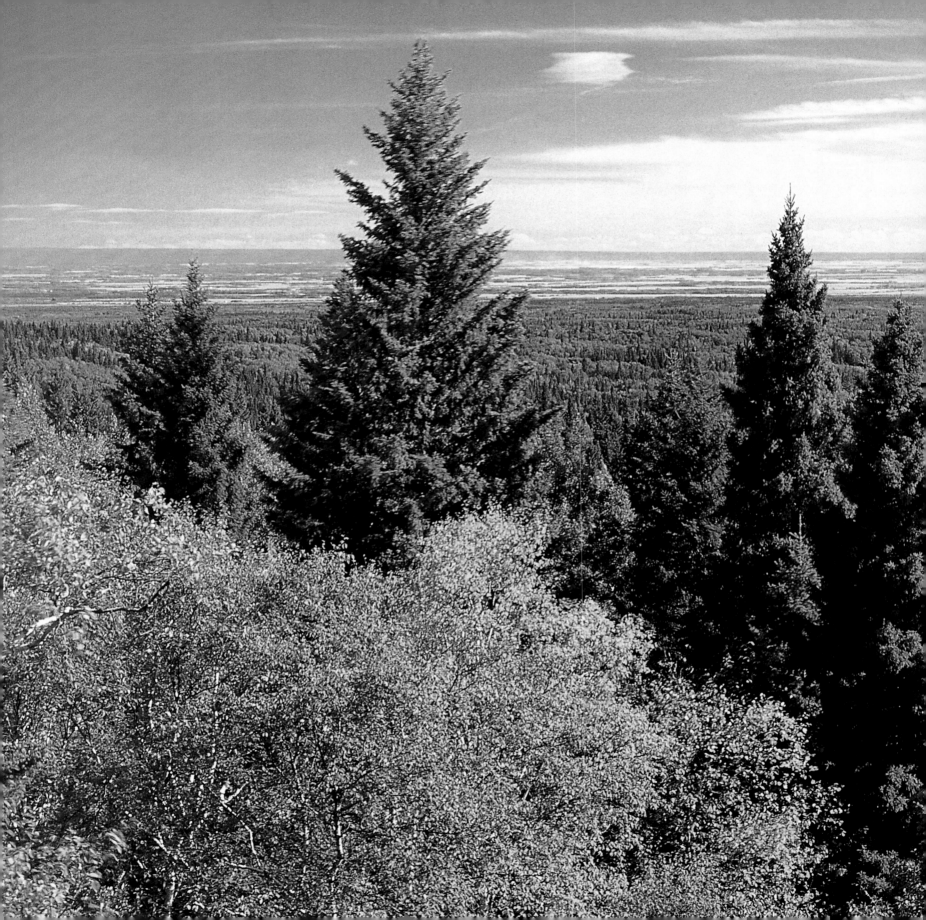

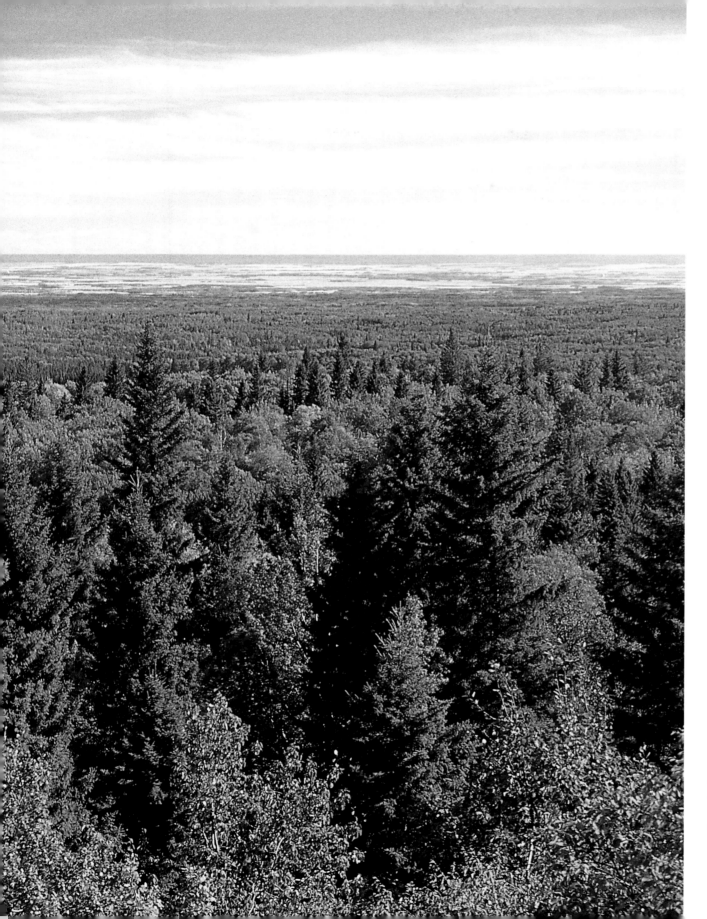

Known as "The Ducks" to Manitoba residents, the forest trails and sparkling lakes of Duck Mountain Provincial Park are home to bear, moose, elk, deer, lynx, coyote, and even wolves.

Visitors might think of Manitoba's grasslands before the province's lakes and rivers, but freshwater fishing here draws enthusiasts from across Canada. The province grants 160,000 licenses each year to anglers who want to try their luck at hooking walleye, catfish, trout, and bass.

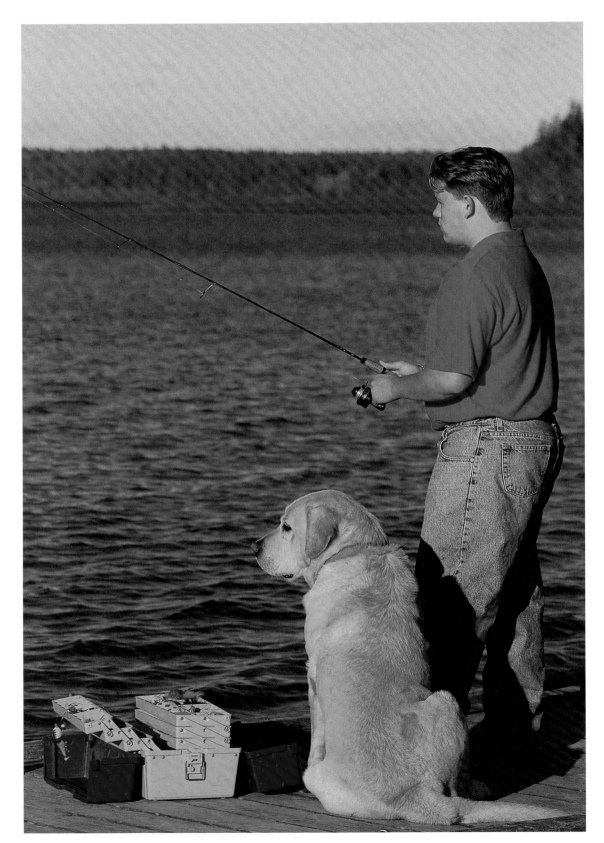

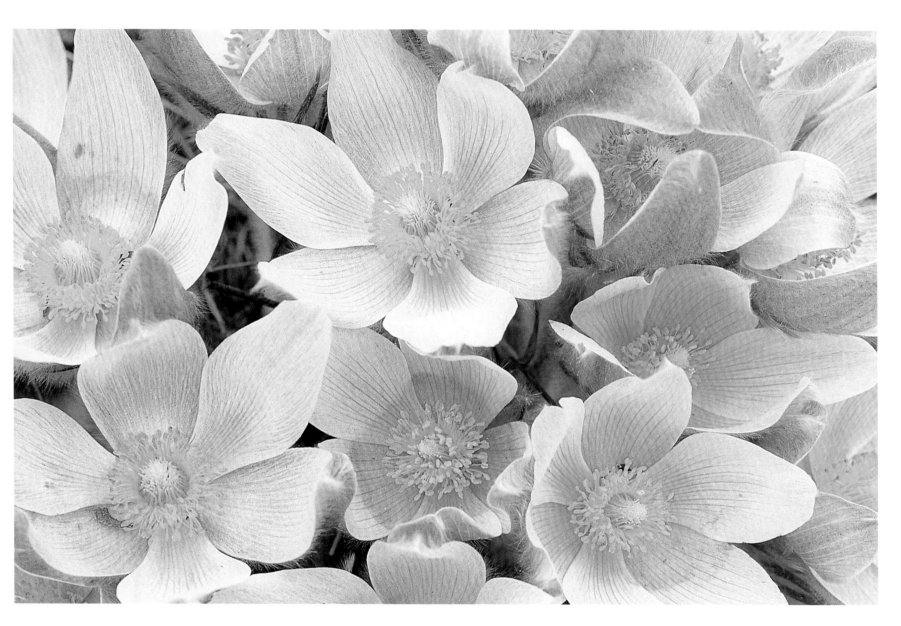

The prairie crocus has been the official flower of the province since 1906. Actually a member of the buttercup family, the plant's small purple flowers appear just after the last snow melts—or occasionally even earlier.

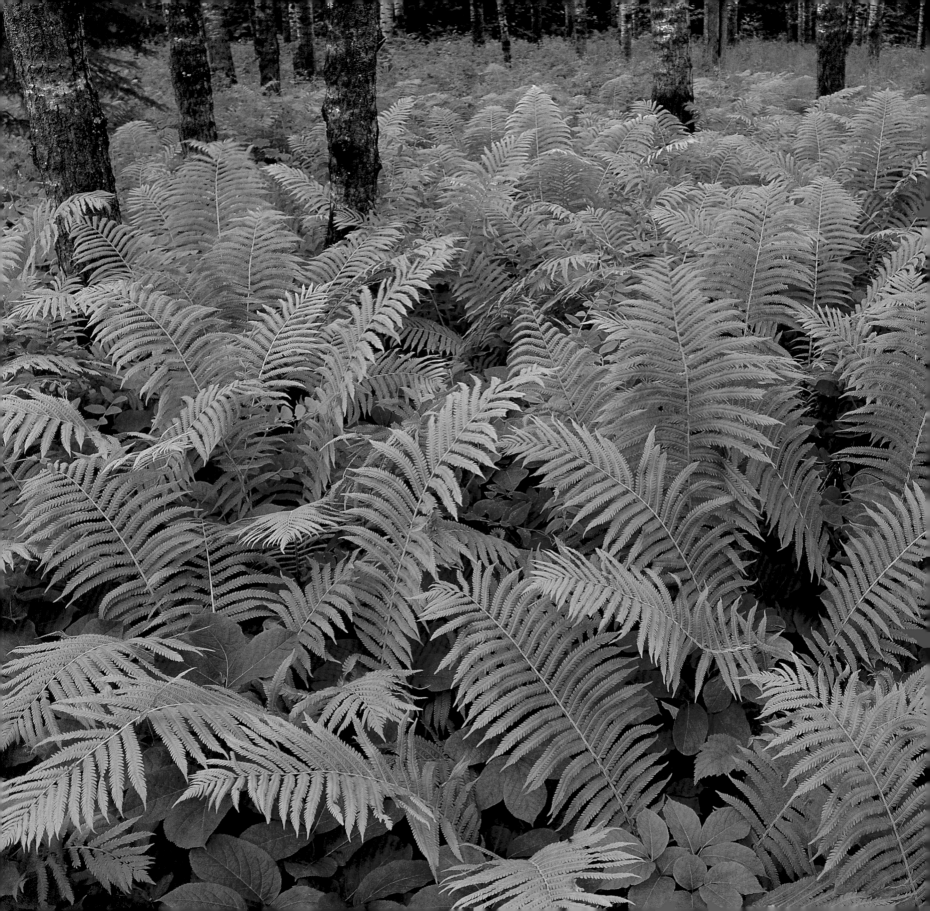

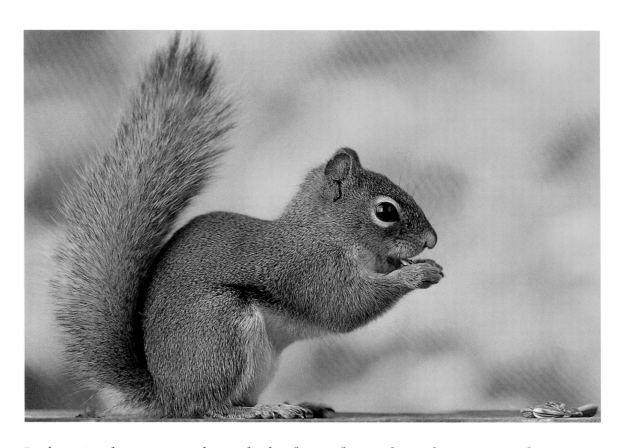

Red squirrels scamper through the forest faster than almost any other animal. They prefer to remain high in the branches, but are easily tempted to ground level by dropped nuts or seeds.

Ferns unfurl in the lush undergrowth along the Birch River. Manitoba's forests are home to many of the province's 90 mammal species, while its creeks and rivers support 115 species of freshwater fish.

The still waters of Clear Lake were a traditional fishing area for the Ojibway First Nations, who hunted and fished throughout the land that is now part of Riding Mountain National Park.

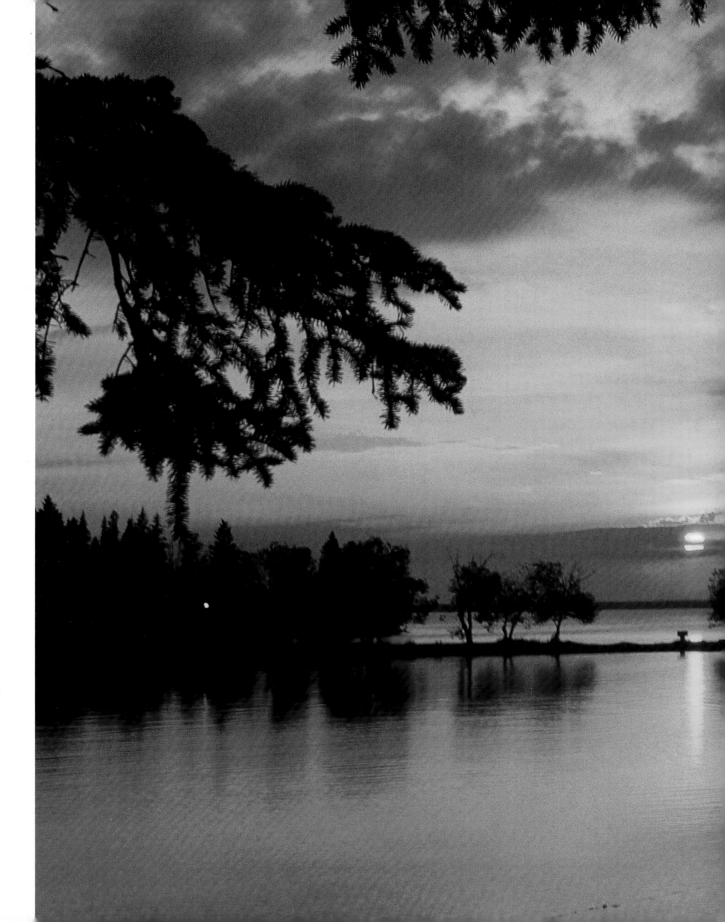

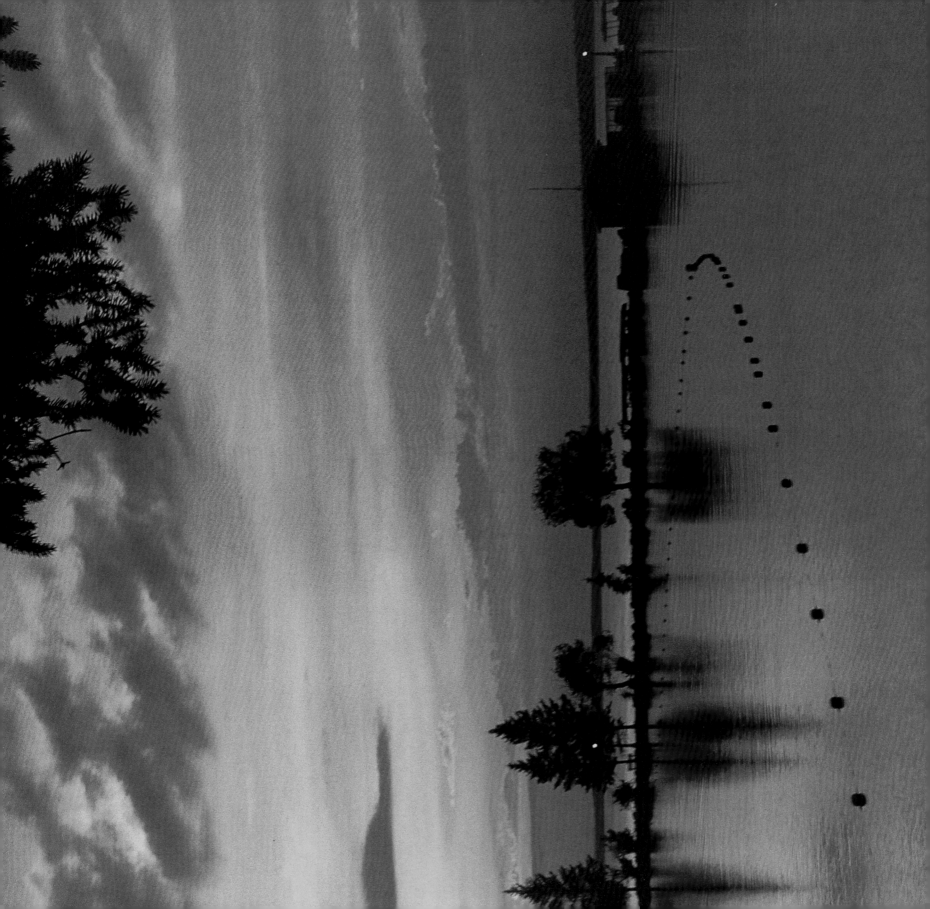

UNESCO has named Riding Mountain National Park a Biosphere Reserve. The park serves as an international model of how humans and nature can coexist.

Stretching over 2,973 square kilometres (1,145 square miles) of the Manitoba Escarpment, Riding Mountain National Park includes eastern deciduous forest, boreal forest and grasslands, all home to diverse plant and animal species.

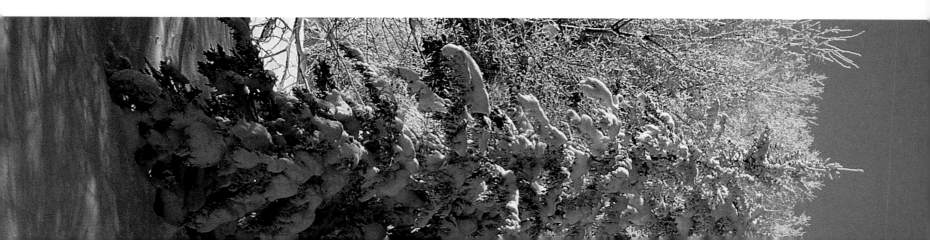

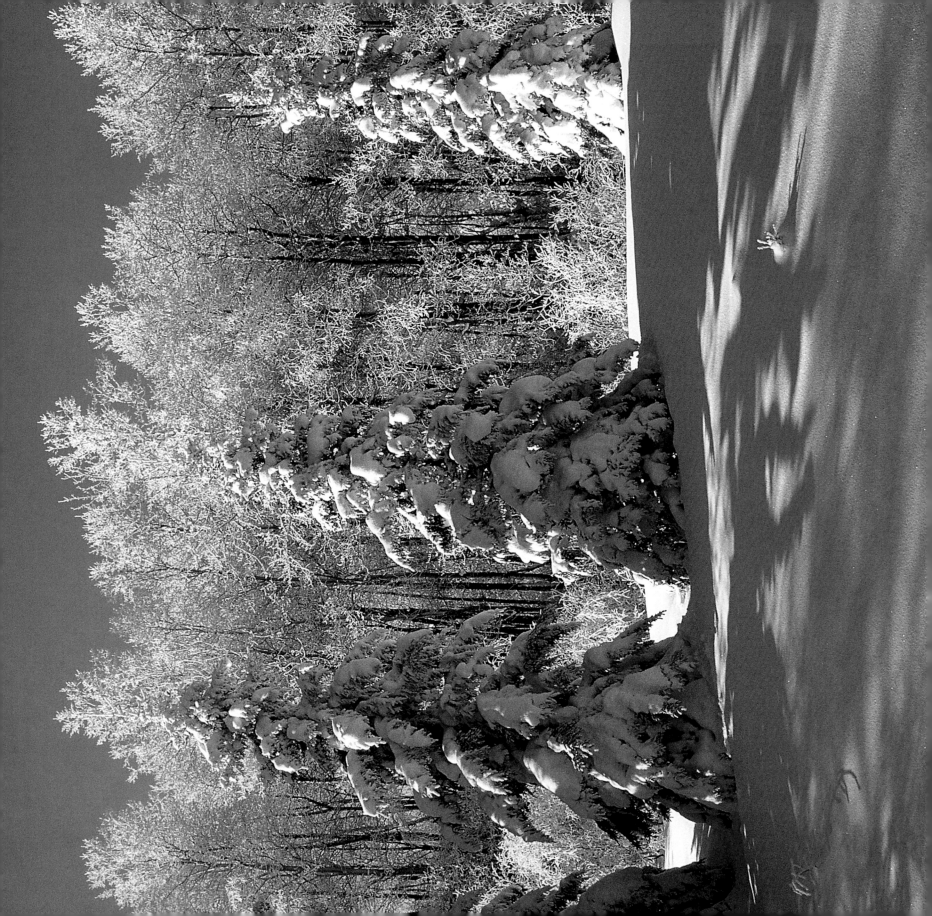

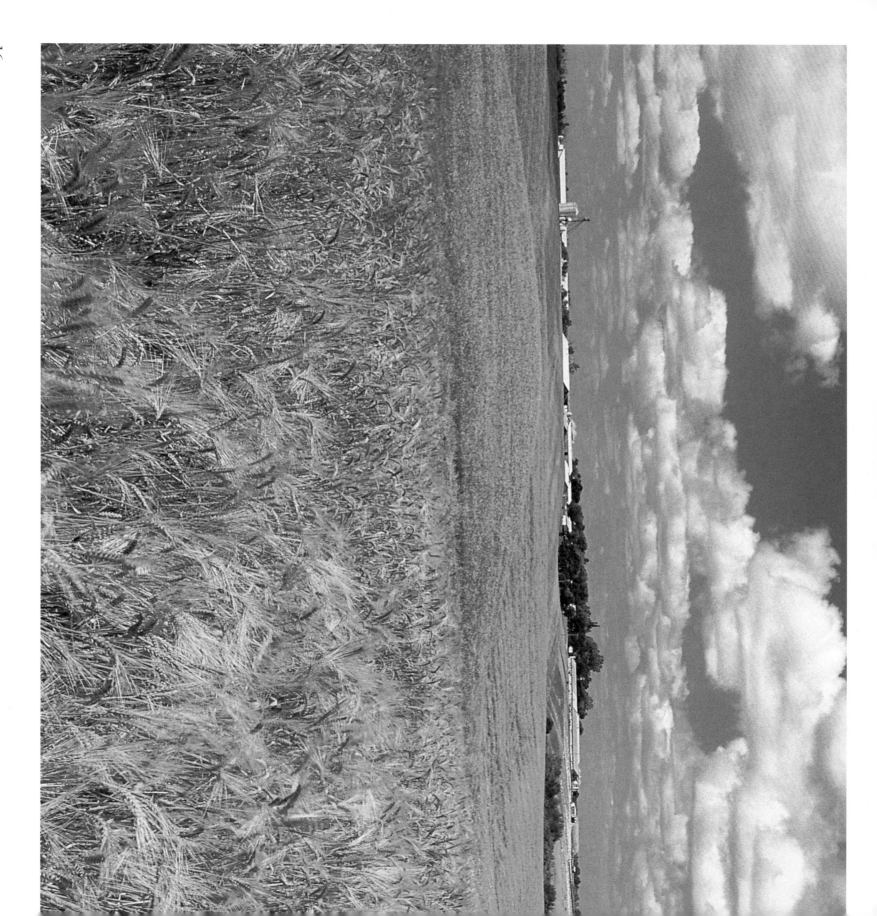

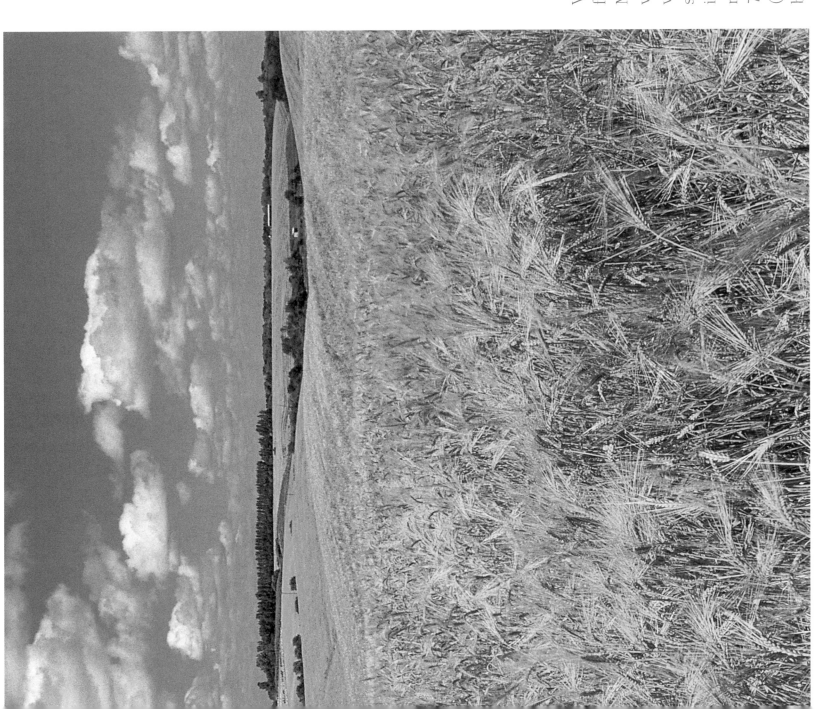

Wind stirs a barley field near Austin. Much of the province was once swamp and wetlands, but extensive drainage and irrigation systems now allow more than 7,690,000 hectares (19 million acres) to be farmed.

A bed and breakfast welcomes visitors to Minnedosa, just north of Brandon. Founded as a North West Mounted Police fort in 1874, the picturesque valley town on the Little Saskatchewan River was also home to the first ethanol plant in Canada.

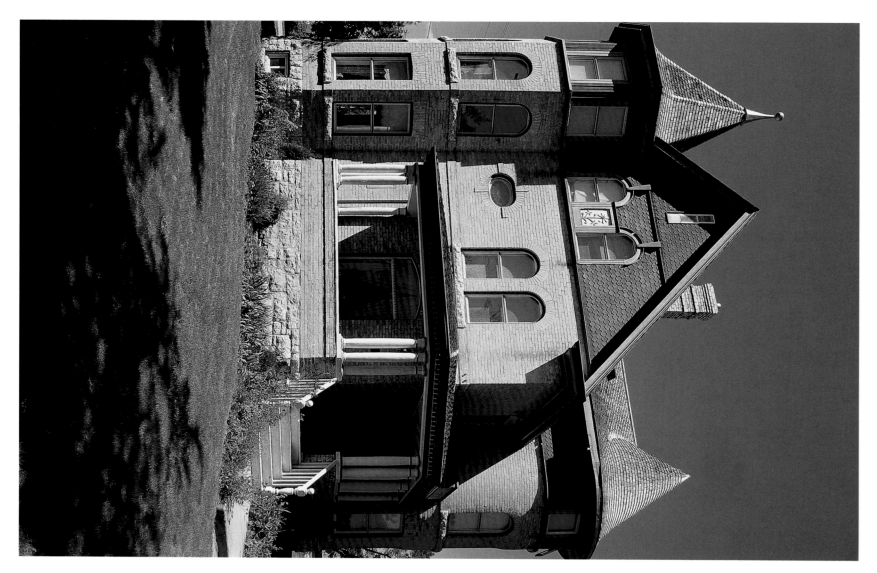

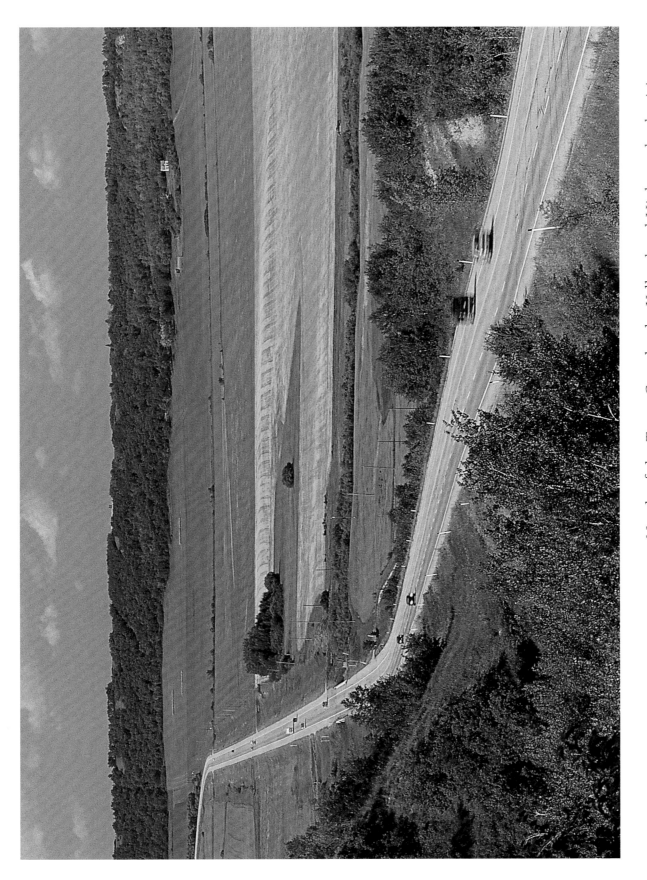

North of the Trans-Canada, the Yellowhead Highway leads visitors from Portage la Prairie, through Saskatchewan and the Rockies to the Pacific. The highway is named for a 19th-century guide and fur trader nicknamed Tete Jaune, or "yellow head."

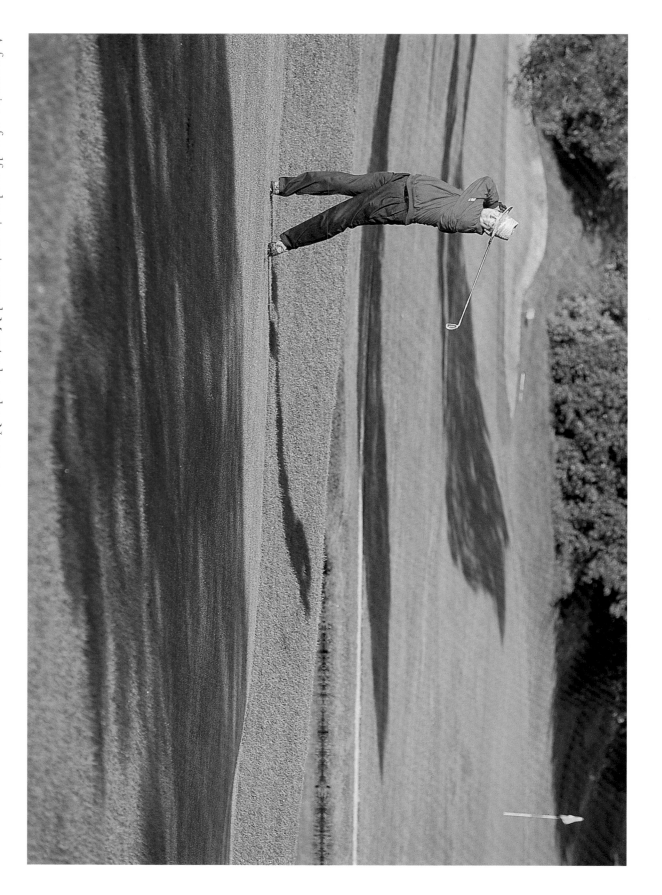

A favourite of golf enthusiasts in rural Manitoba, the Neepawa Golf and Country Club features nine challenging holes set amid beautifully manicured lawns and gardens.

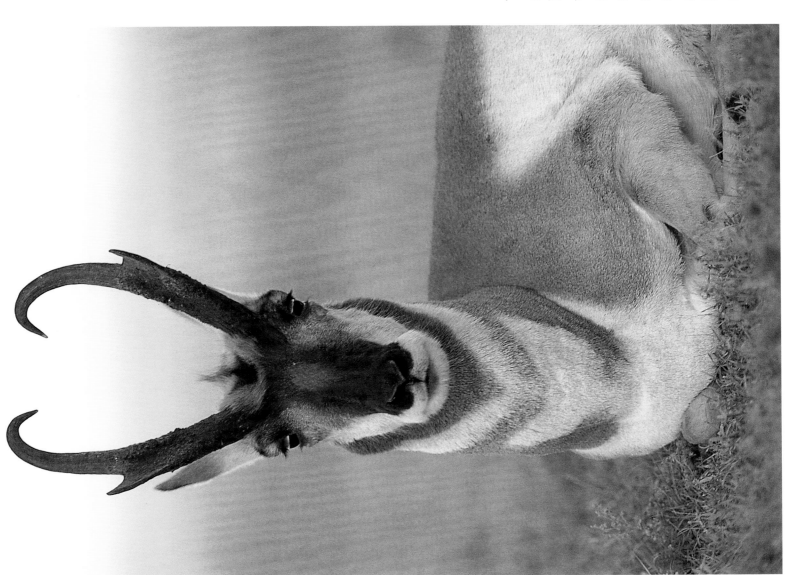

The pronghorn is one of the fastest land animals in the world; only the cheetah is faster. This agile relative of the antelope can achieve speeds of 98 kilometres (61 miles) per hour over Manitoba's open grasslands.

21

One of Canada's most famous novelists and author of *The Diviners*, Margaret Laurence was born in Neepawa in 1926 and grew up in her grandfather's large home. The house is now a provincial heritage site and museum, open to fans since 1986.

Sunflowers were cultivated by North American First Nations long before the arrival of Europeans. Manitoba now produces more than 70 percent of Canada's crop.

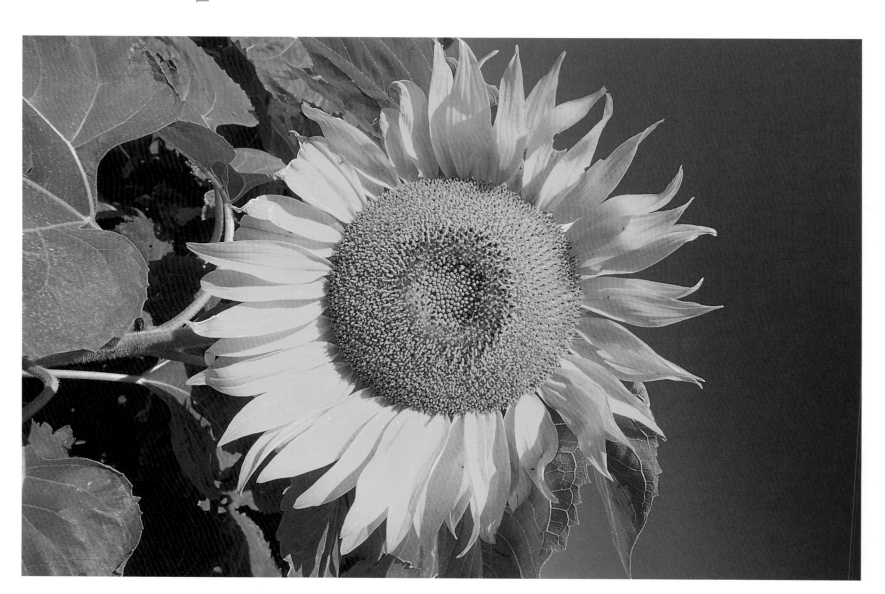

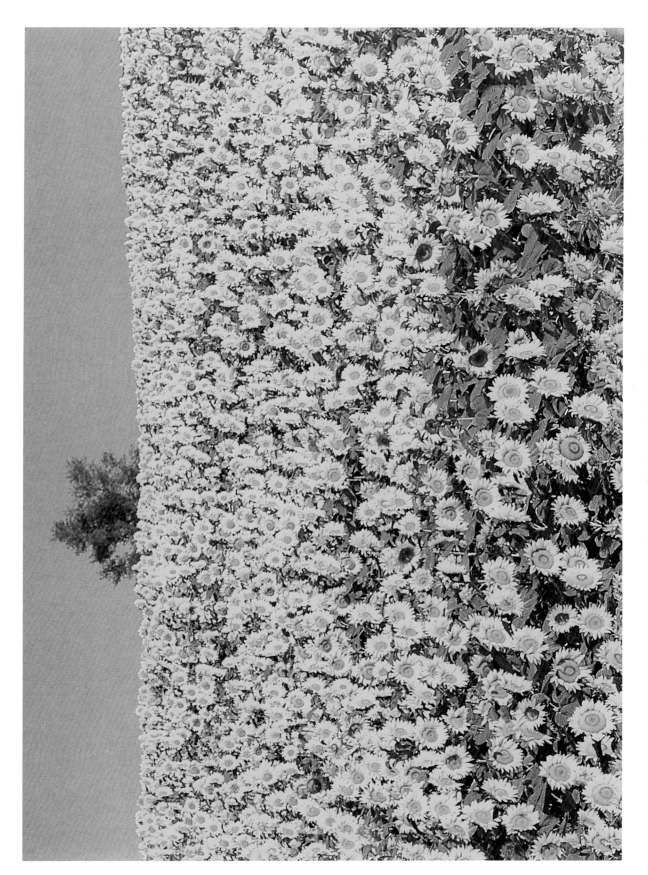

Many of Manitoba's sunflower crops are grown to produce oil—each seed is 40 to 50 percent oil. Sunflower seeds are also used in food products, birdfeed, and animal feed.

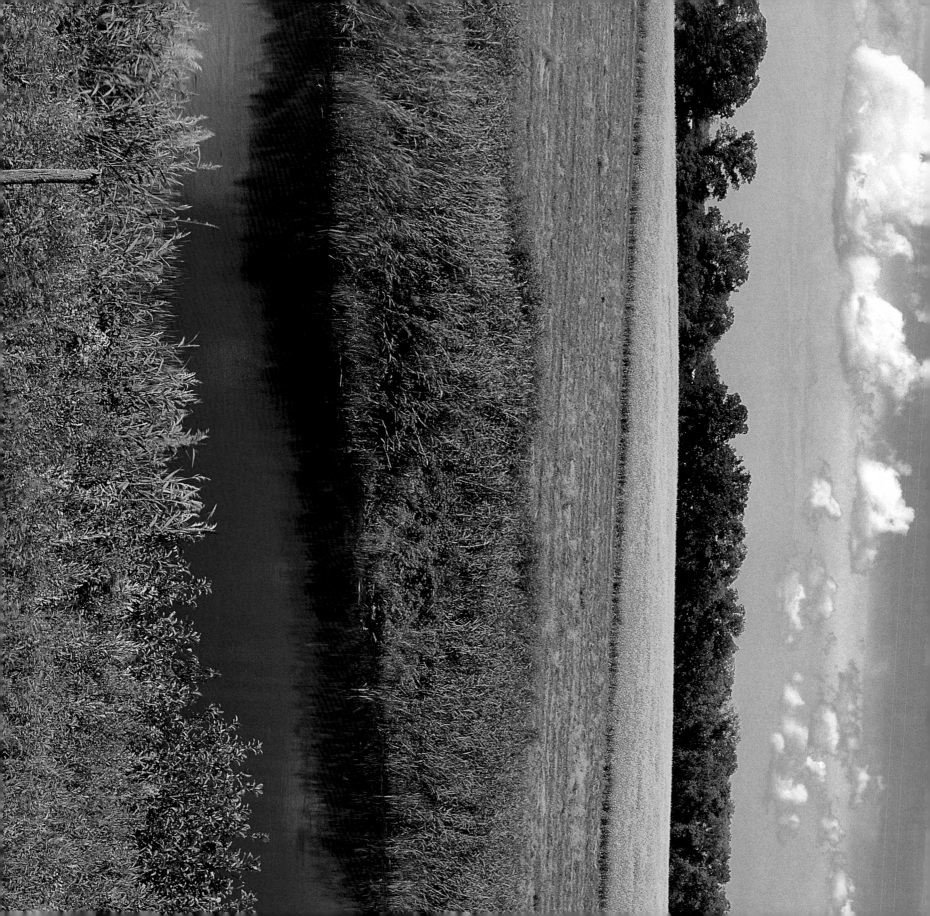

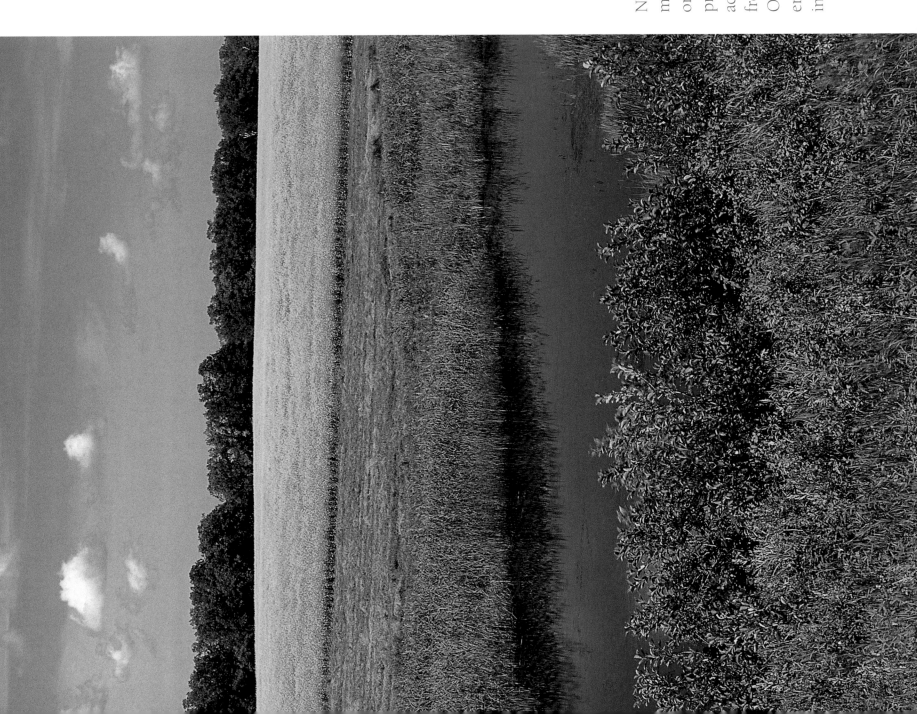

None of Manitoba's major river systems originate within the province. They flow across the prairie from the Rockies, Ontario, or the northern states and empty into Hudson Bay.

27

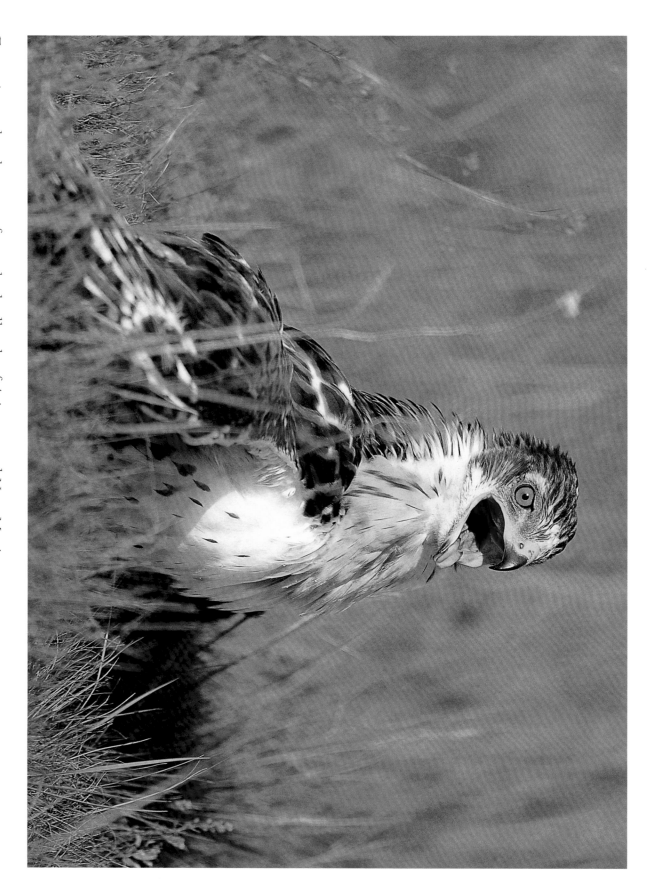

Ferruginous hawks range from the badlands of Arizona and New Mexico to the grasslands of the Canadian prairies. This juvenile hawk will remain close to its mother until it can successfully hunt small rodents by itself.

28

Onion-domed spires such as this one in Oakburn mark Ukrainian settlements across the prairies. The first Ukrainians to arrive in Canada were Wasyl Elyniak and Ivan Pylypiw in 1891. By 1900, there were already six Ukrainian-Catholic church parishes across the country.

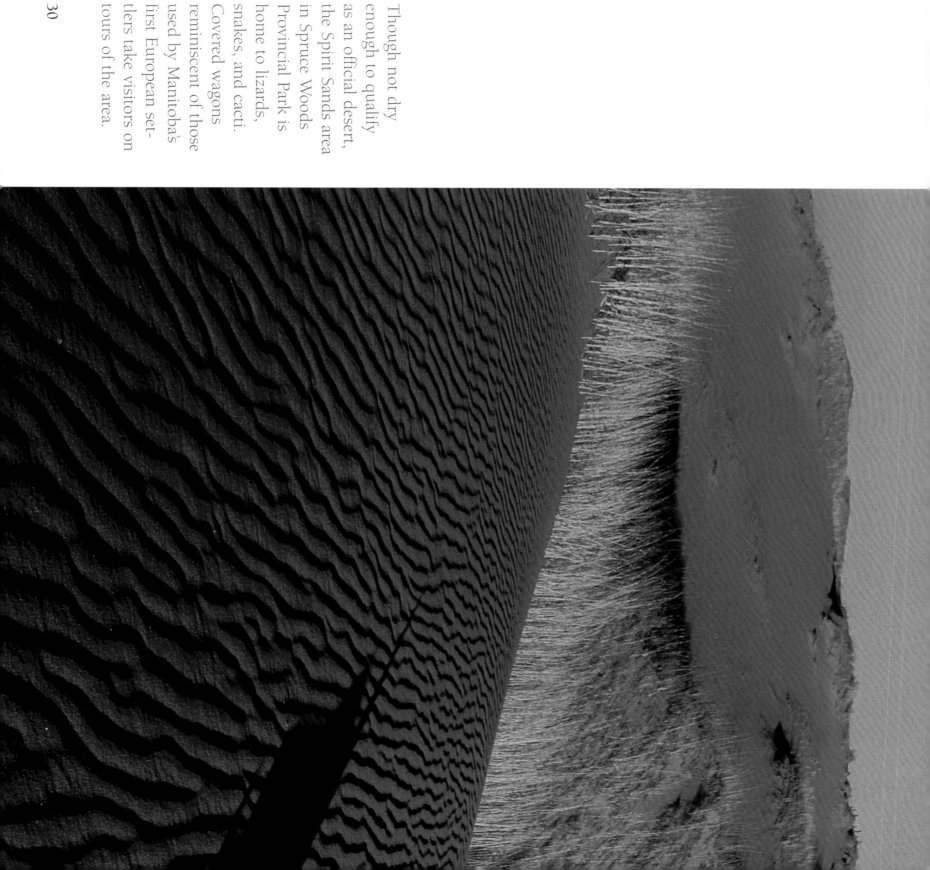

Though not dry enough to qualify as an official desert, the Spirit Sands area in Spruce Woods Provincial Park is home to lizards, snakes, and cacti. Covered wagons reminiscent of those used by Manitoba's first European settlers take visitors on tours of the area.

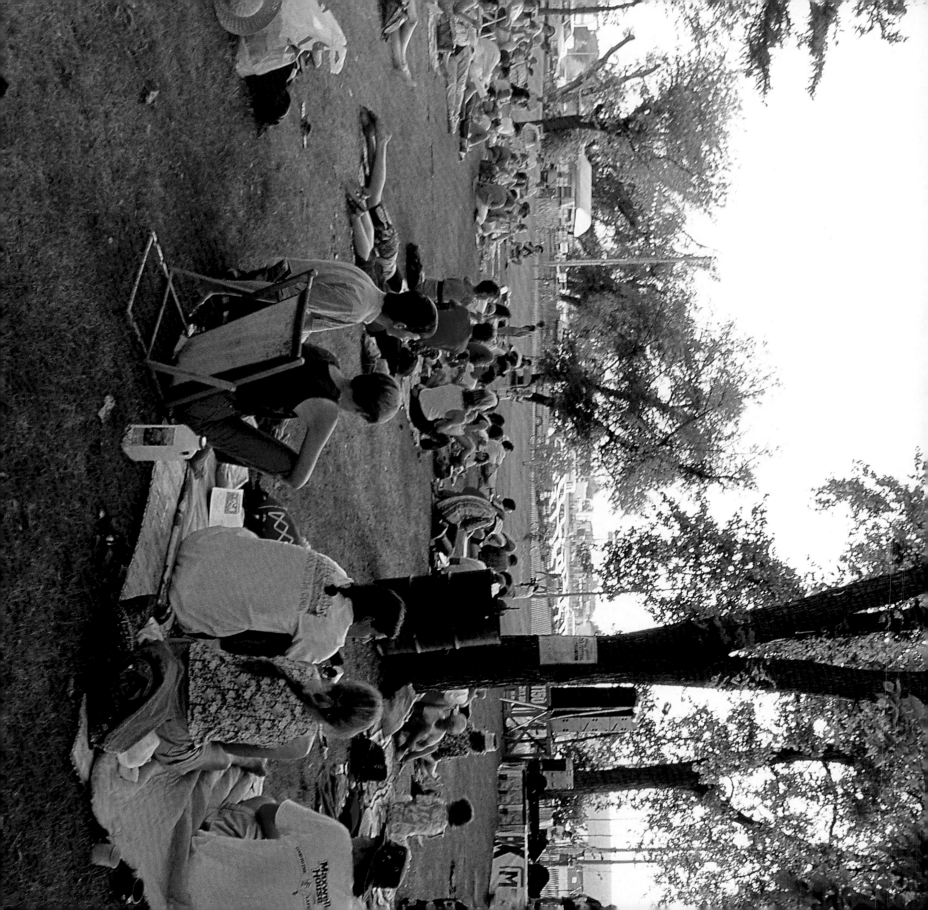

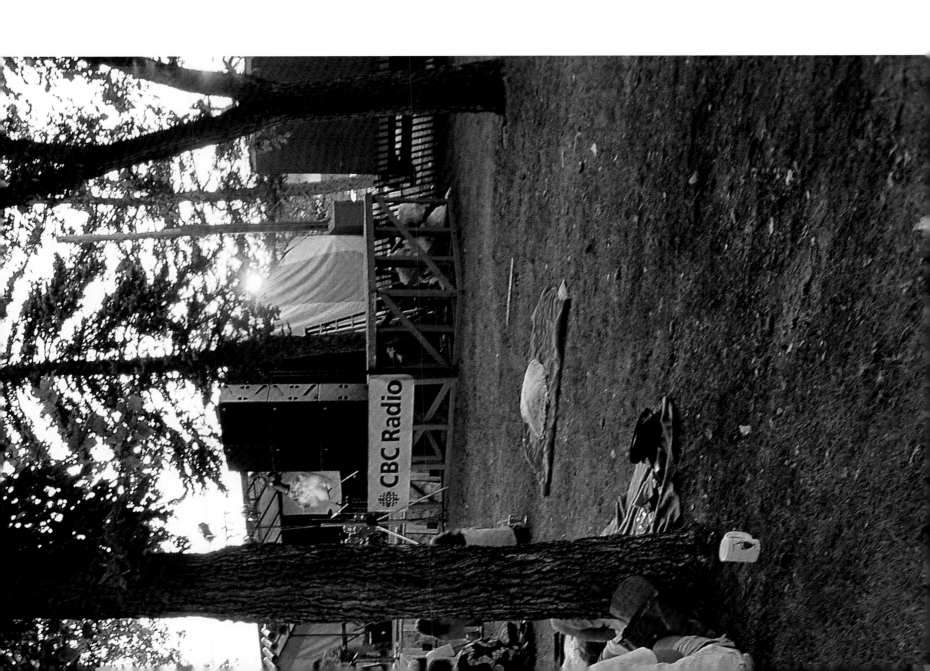

Musicians, artists, and community groups from Manitoba and around the world take part in the Brandon Folk Music Festival each summer. The largest event of its kind outside Winnipeg, the festival strives to bring alternative groups to centre stage.

33

Flax is used as a grain in many baked goods. The linseed oil exracted from the plants is used in oil paints, wood stains, and varnishes, and flax fibre is used to strengthen paper, plant pots, and mats.

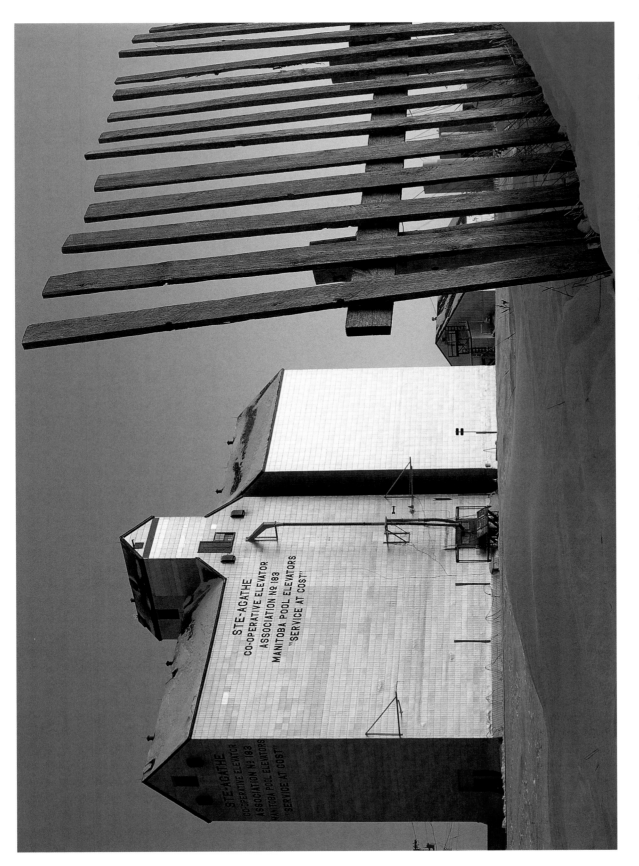

Southern Manitoba was covered by huge glacial lakes at the end of the last ice age. Today, this area is still closely tied to water. Ste. Agathe, a town of 5,000 along the Red River, is one of the first communities threatened when the river overruns its banks.

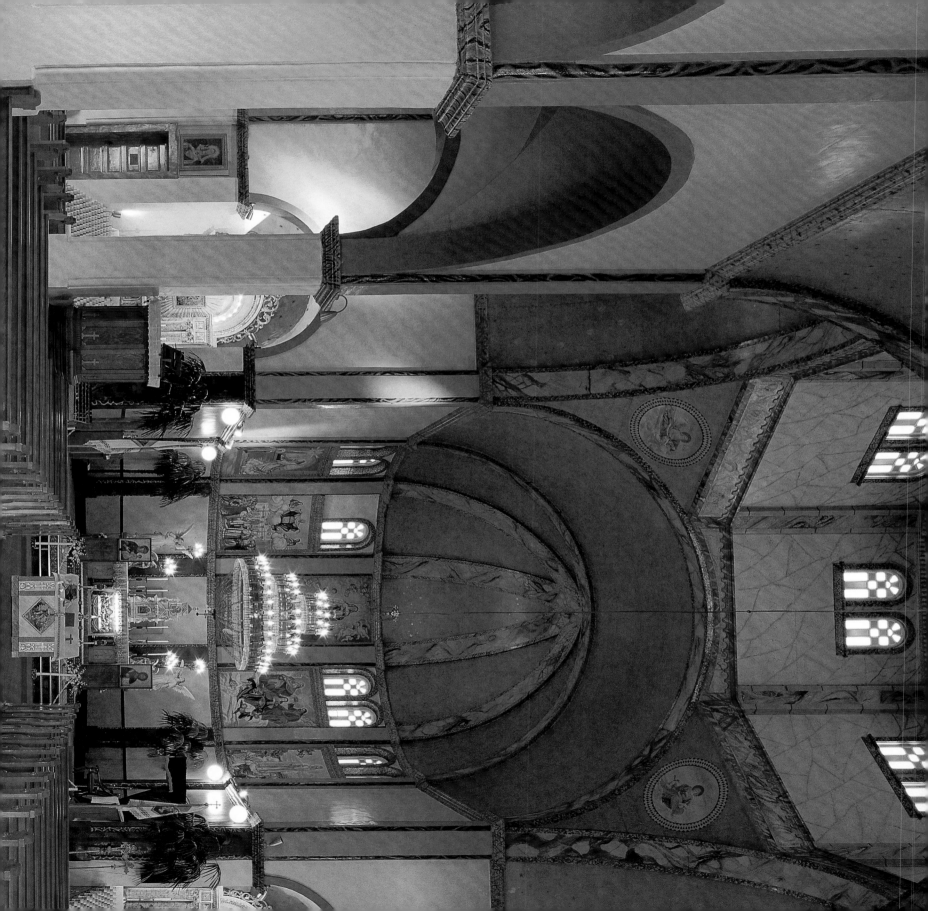

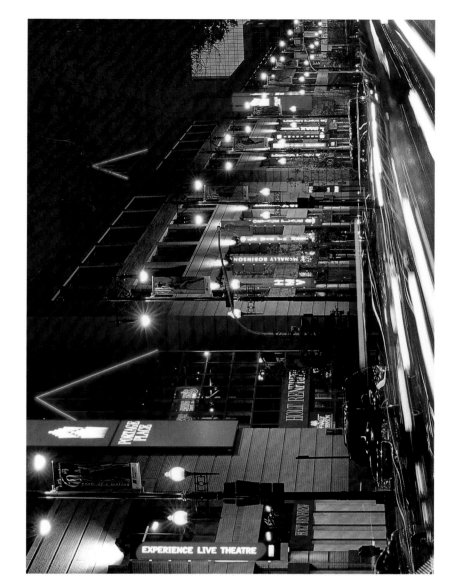

Portage Avenue, one of Winnipeg's main streets, is part of a 19th-century trail extending west as far as Edmonton. The corner of Portage and Main is said to be the windiest corner in Canada.

The Immaculate Conception Church in Cooks Creek was built by the Ukrainian Catholic congregation of Father Philip Ruh O. M. I. They began with few funds in 1930, and completed the structure 22 years later. It is now a provincial heritage site.

Sunrise highlights the power lines near Headingley, just outside of Winnipeg. The harnessing of Manitoba's most powerful waterways, including Nelson River, provides much of the province's electricity.

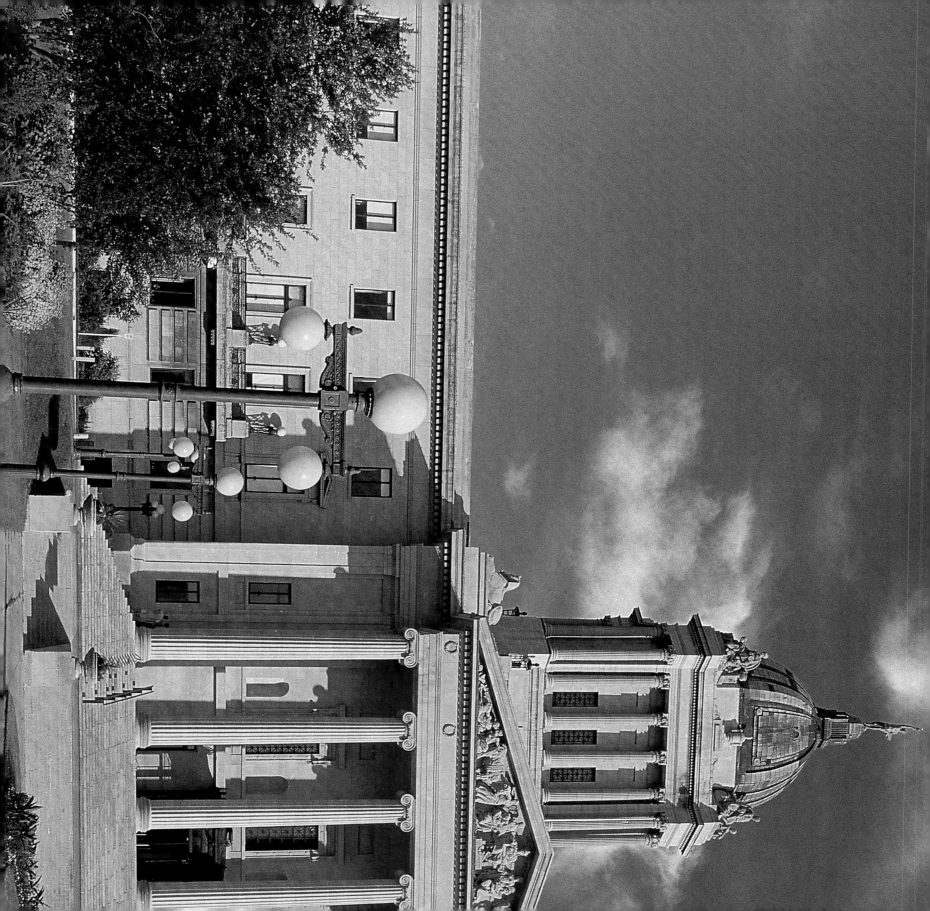

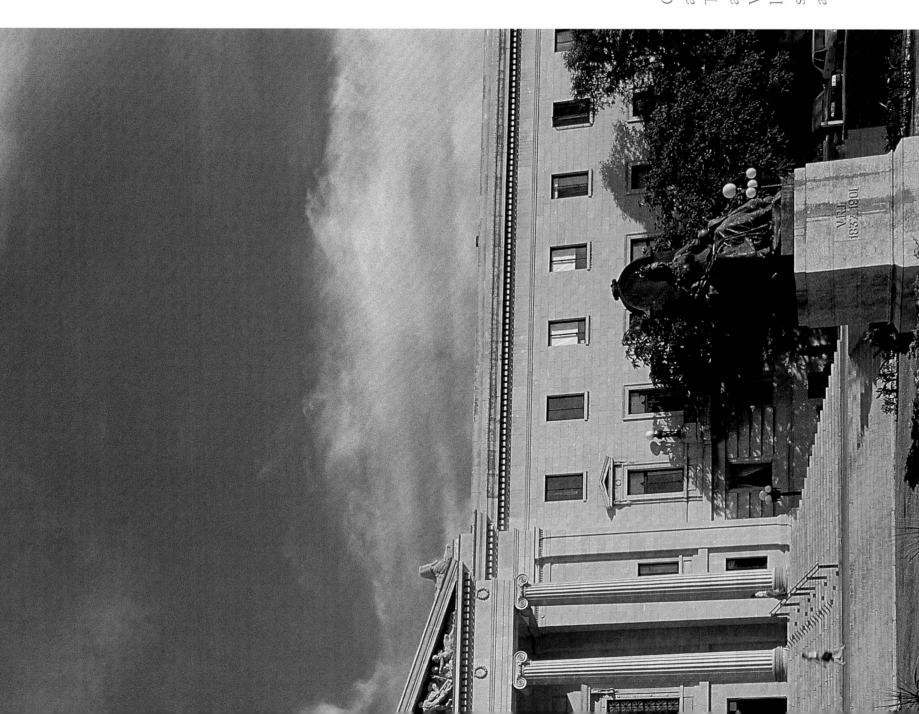

Completed in 1919 and built with rare Tyndall stone and a neoclassical style, Winnipeg's Legislative Building is studied by architects around the world.

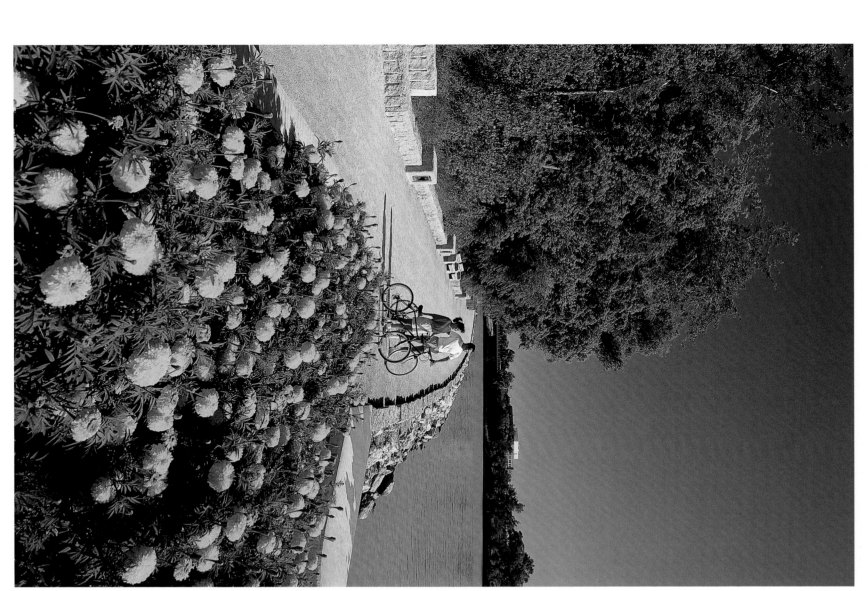

Cyclists enjoy a quiet ride from the centre of the city to the Legislative Building along the winding riverwalk.

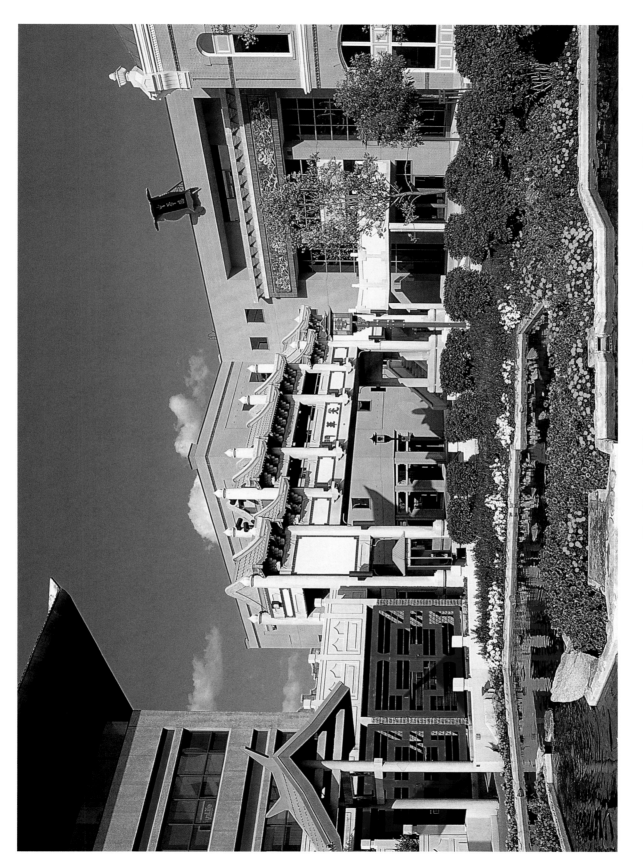

Traditional Chinese gardens surround the Dynasty Building in Winnipeg's Chinatown. The city's first Chinese residents arrived in 1877 and Chinatown was established in 1909.

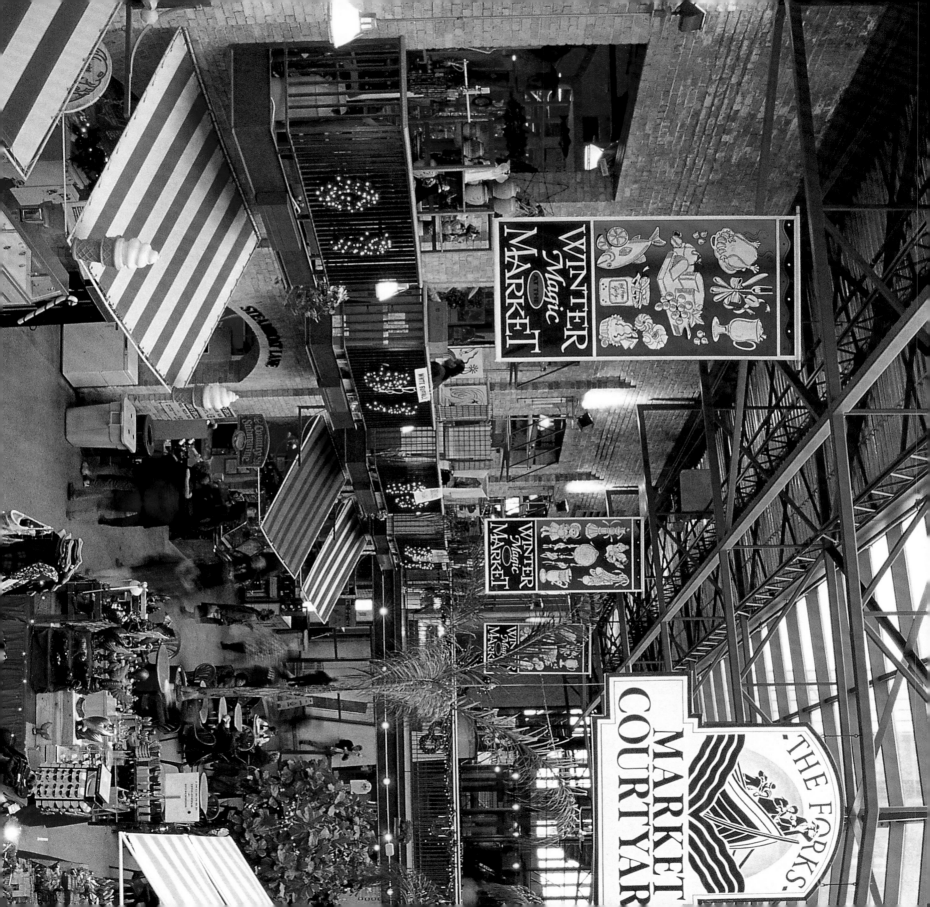

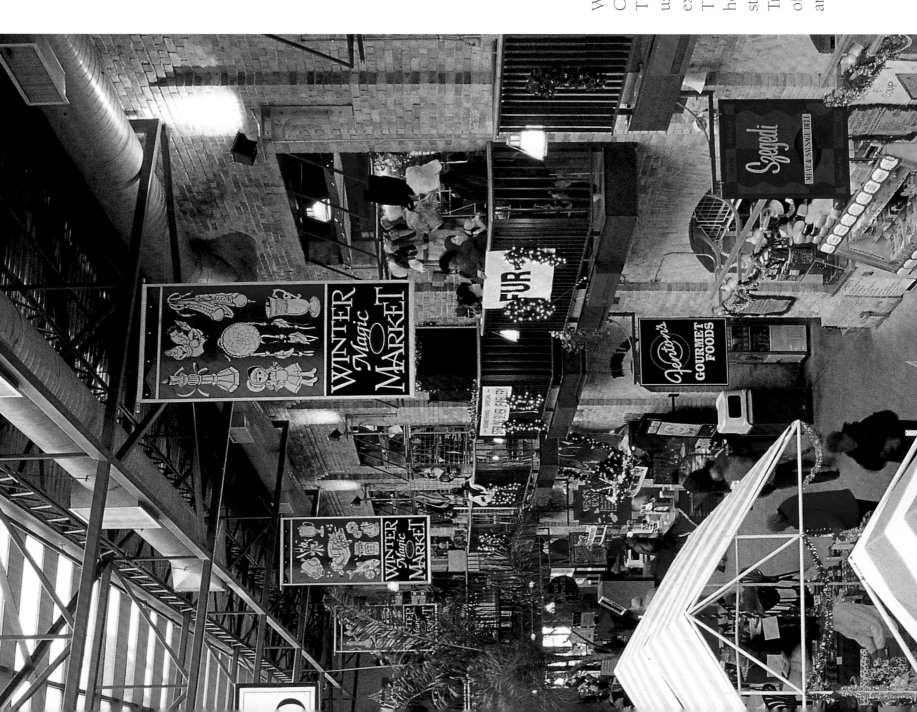

Winnipeg's City Centre is known as The Forks, a name used by French explorer La Vérendrye. The Forks Market, housed in the old stable of the Grand Trunk Pacific Railway, offers an array of local and exotic foods.

When the Hudson's Bay Company was negotiating the transfer of Manitoba to the Canadian government, the population of the region was about 90 percent Métis. Louis Riel led his people in a valiant effort to protect their rights and their land.

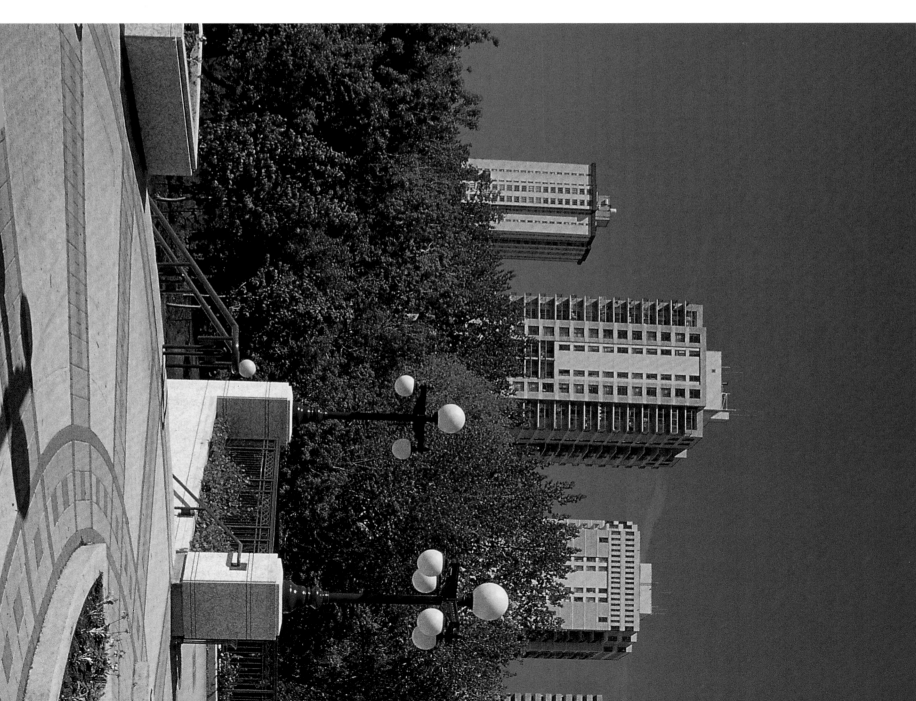

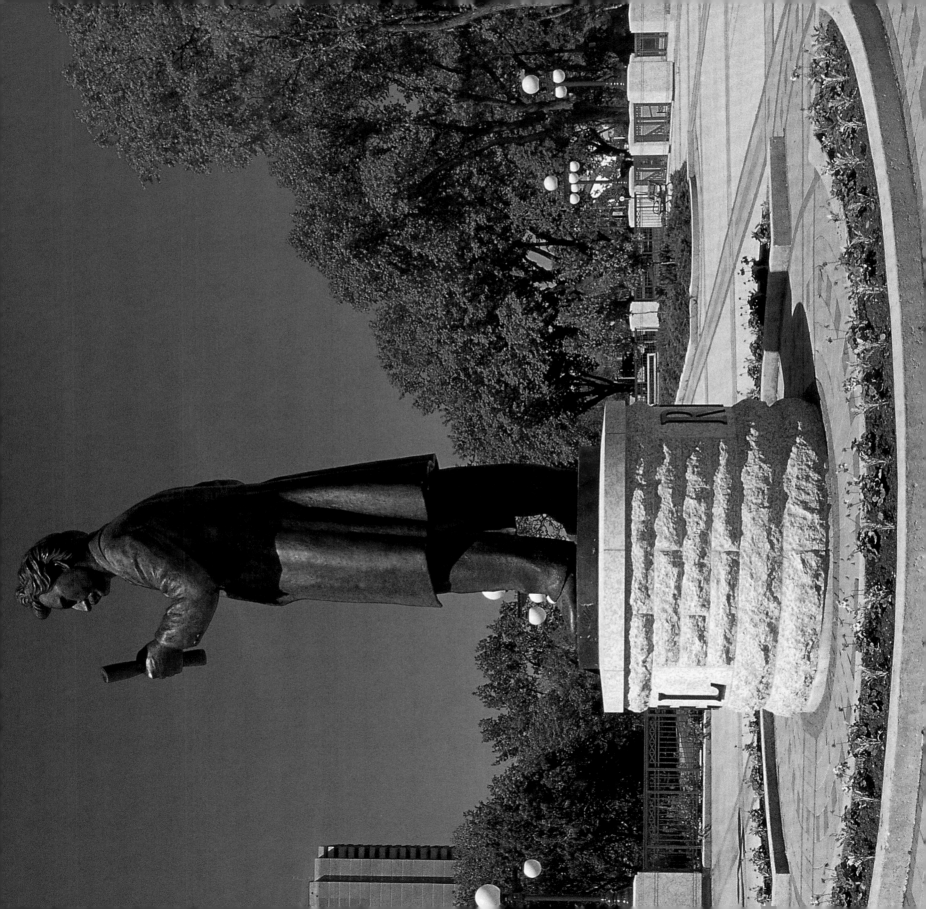

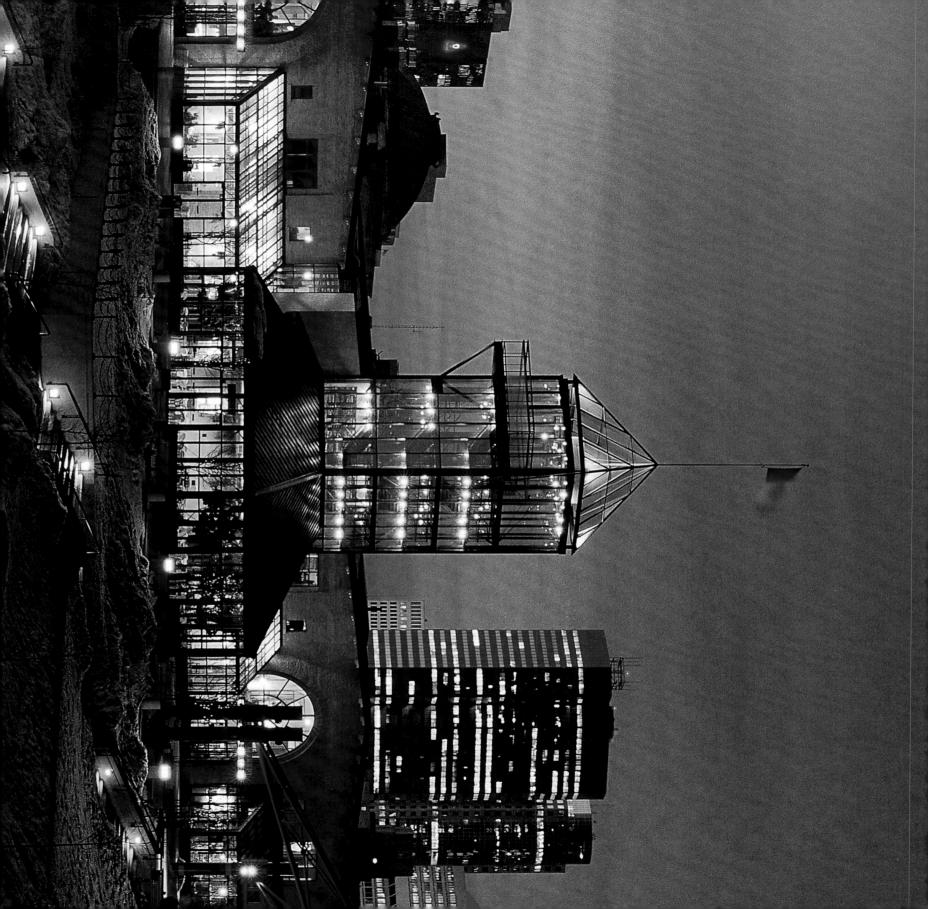

The Royal Canadian Mint boasts some of the world's most advanced currency-making technology. Each year, the facility makes up to three billion coins—enough for Canada and a dozen other countries.

While new development brightens the future of The Forks, archaeologists and volunteers continue to delve into the past, uncovering evidence of First Nations trading here thousands of years ago.

50

Bison and monkeys, lynx and Siberian tigers share the sprawling grounds of the Assiniboine Park Zoo. More than 1,200 animals from Manitoba and around the world are housed here.

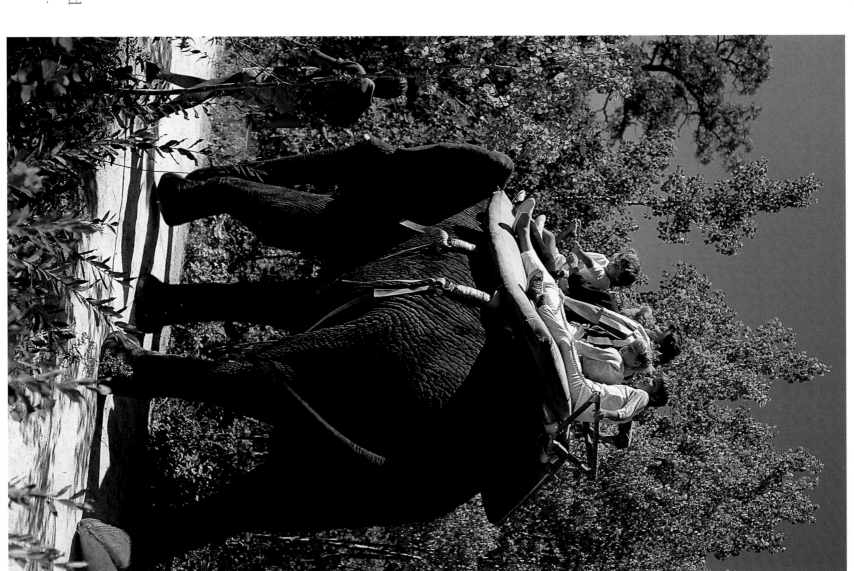

The creation of Assiniboine Park in 1909 was one of the first acts of Winnipeg's newly formed Parks Board. The preserve includes an English garden, formal gardens, the Leo Mol Sculpture Garden, a conservatory, a zoo, and more.

51

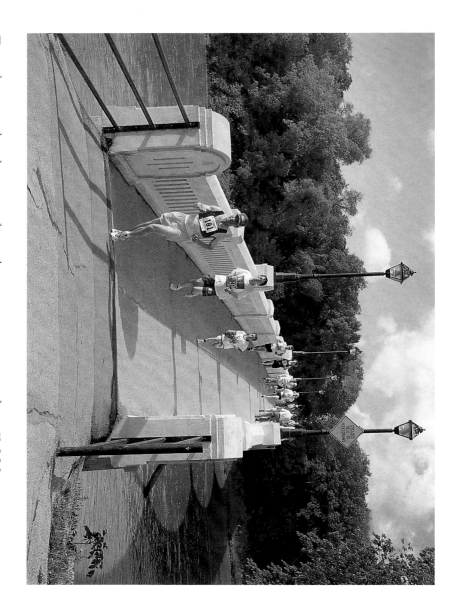

Two thousand volunteers line the routes as more than 7,000 runners participate in the annual Manitoba Marathon. Five consecutive races of varying lengths are held on the same day.

Lower Fort Garry served as a military base during the Riel Resistance. It is now a national historic site, and visitors can wander from the governor's house to the blacksmith's, experiencing life in the 19th century.

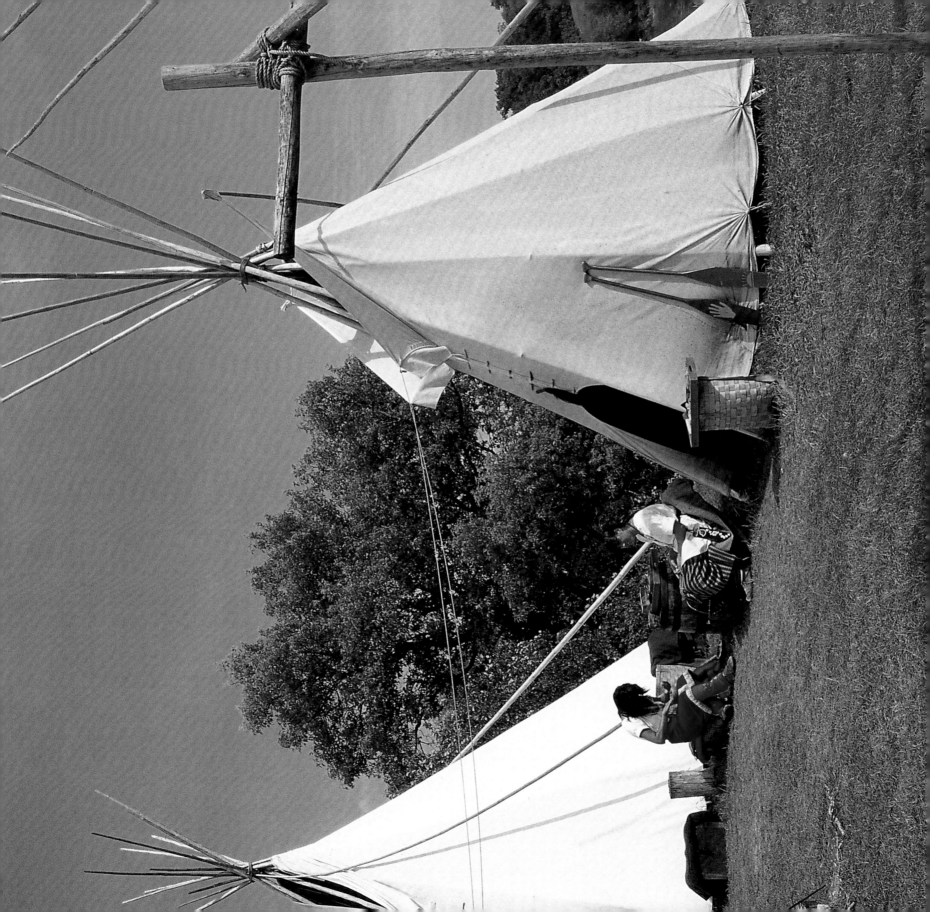

From remnants of the fur trade to the workings of the boreal forest, the Manitoba Museum of Man and Nature explores the relationship of people with the world around them throughout Canadian history.

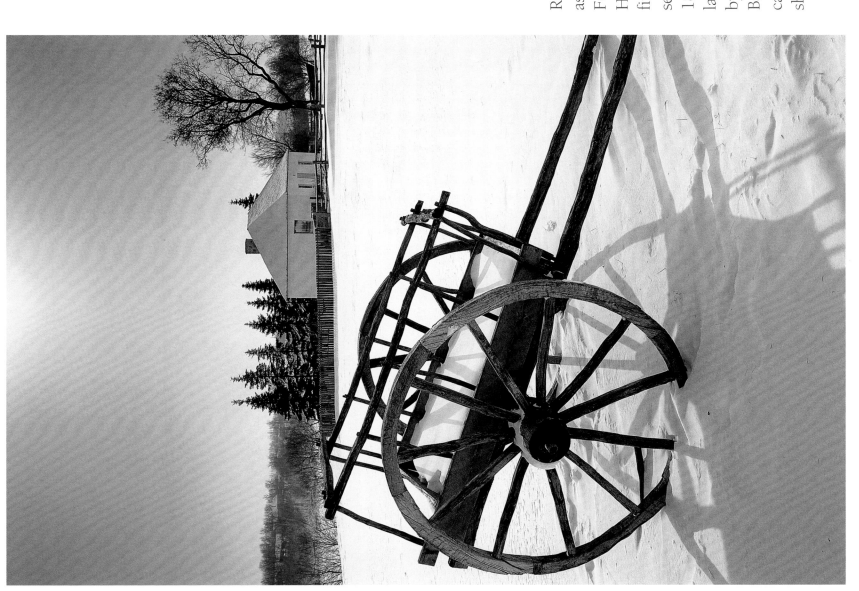

Red River carts such as this one at Lower Fort Garry National Historic Site were first used by prairie settlers in the early 1800s. They were later used extensively by the Hudson's Bay Company to carry furs to their shipping routes.

The St. Boniface Cathedral was built in 1908, but much of the original building was destroyed by fire in 1968. The rebuilt structure, finished in 1972, is a provincial heritage site.

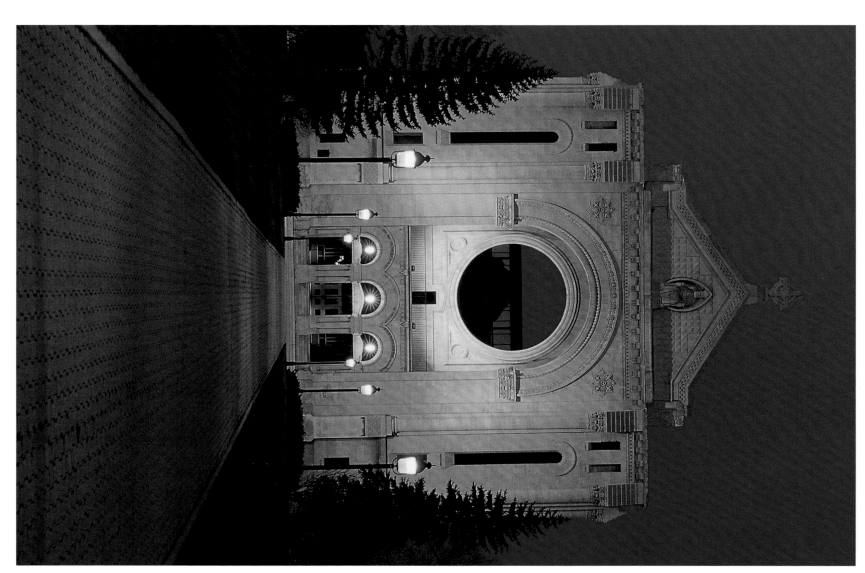

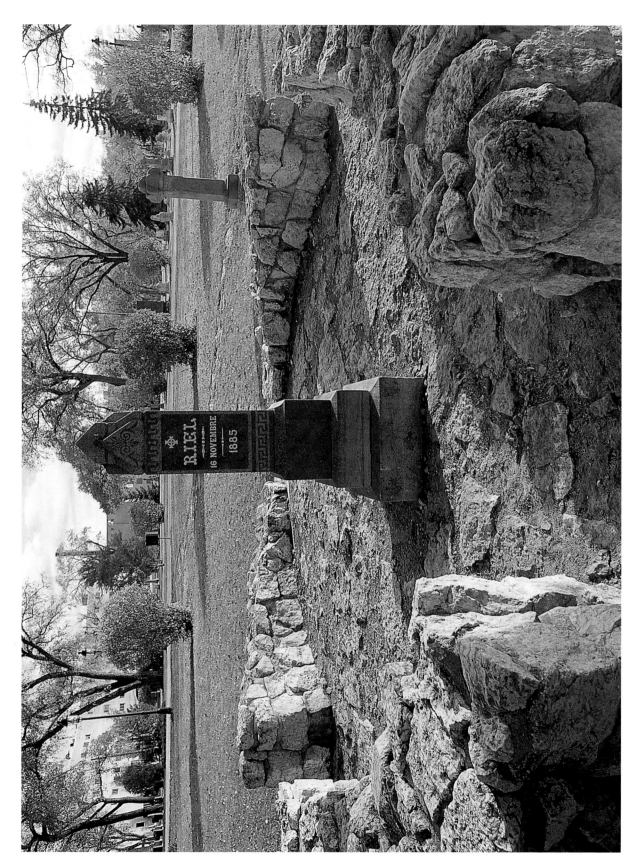

Louis Riel is buried in the churchyard of St. Boniface Cathedral. After his execution in Regina in 1885, emotions were so high that his body had to be secretly transported to his family home in Manitoba.

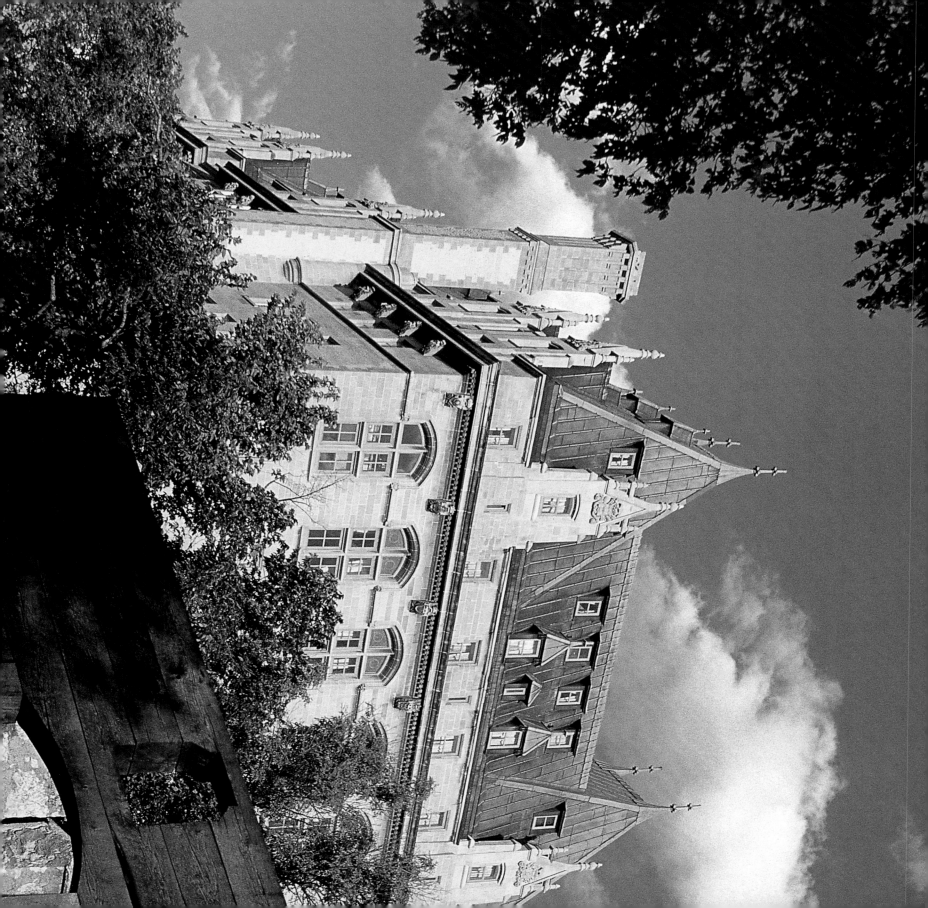

This stone gate is all that remains of Upper Fort Garry, a 19th-century Hudson's Bay Company post. From here, the company oversaw the fur trade in the Red River Valley and farther west. Hotel Fort Garry, built between 1911 and 1913, stands behind the gate.

Archaeologists believe that First Nations people planted corn and other crops in Manitoba as early as A.D. 1100. Possibly because of changes in climate, they abandoned agriculture and returned to a nomadic life within four to five centuries.

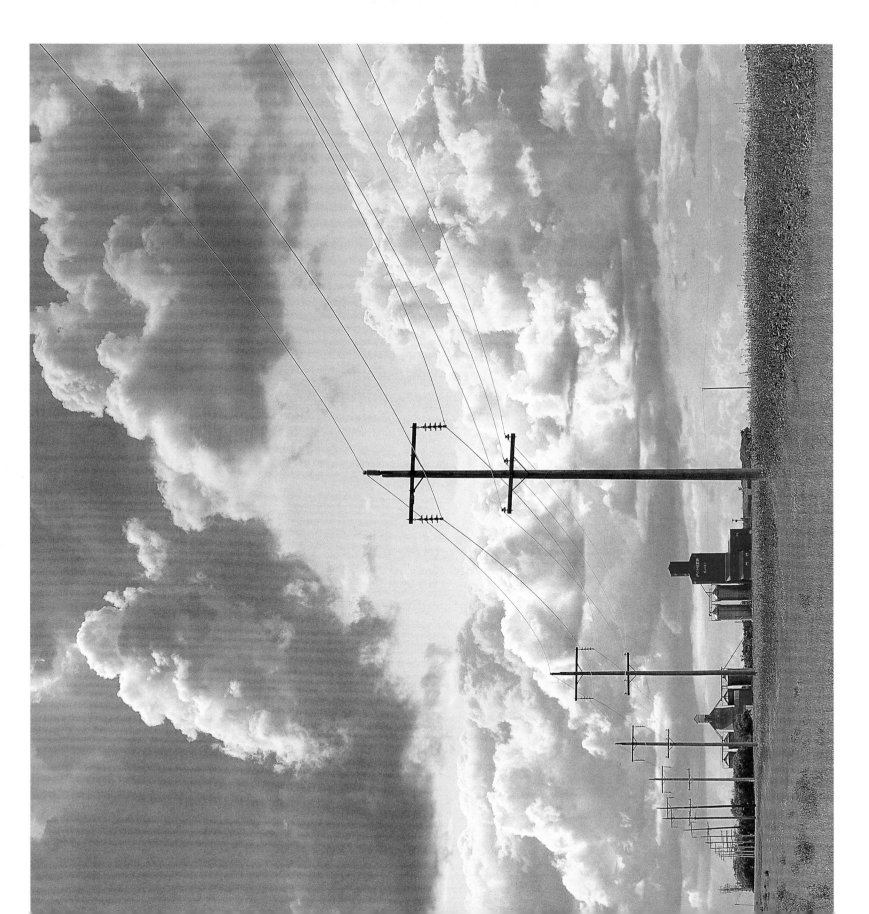

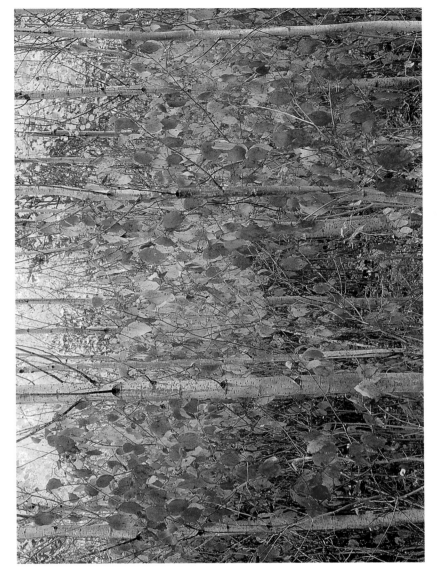

Fall colours paint a stand of aspen in Whiteshell Provincial Park. This varied preserve boasts facilities for swimming, hiking, tennis, golf on a picturesque 18-hole course, and more.

Fiddling and ice sculpting, raccoon hats and beaded moccasins—the Festival du Voyageur sweeps St. Boniface into a frenzy of activity each February.

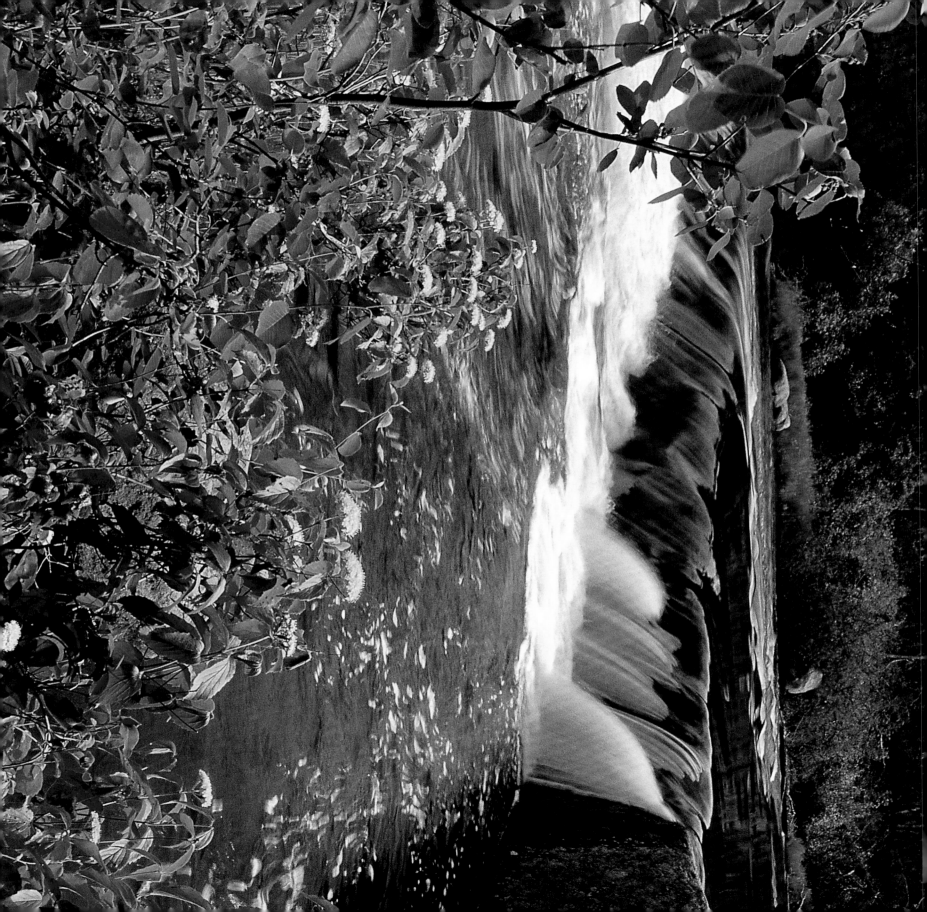

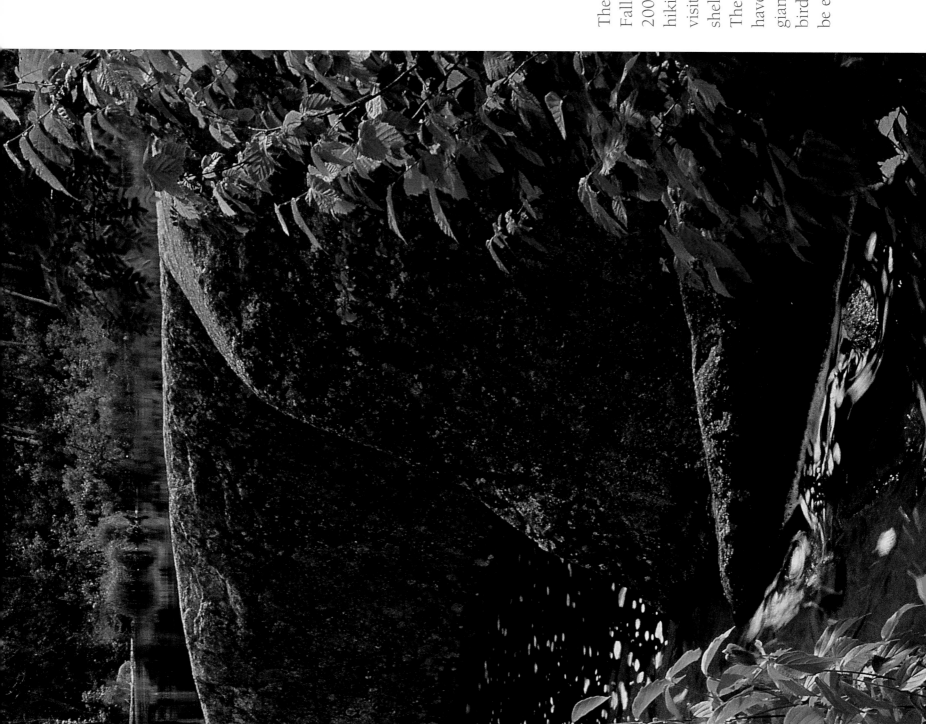

The lovely Rainbow Falls, more than 200 lakes, and 15 hiking trails attract visitors to Whiteshell Provincial Park. The park is also a haven for a flock of giant Canada geese, a bird once thought to be extinct.

66

When the province of Manitoba was established in 1870, it was a small fraction of its current size and was dubbed "the postage stamp province." The final boundaries were established in 1912.

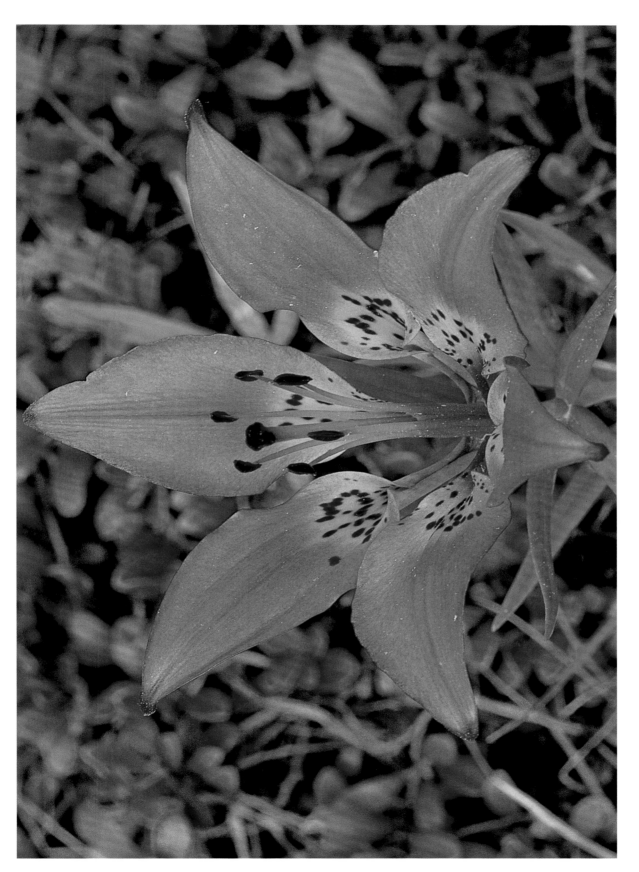

Quilters know the wood lily for the pattern it has inspired—a complicated diamond-shaped star. This is one of Manitoba's most loved wildflowers. The town of Neepawa has even dedicated a week-long Lily Festival to the bloom.

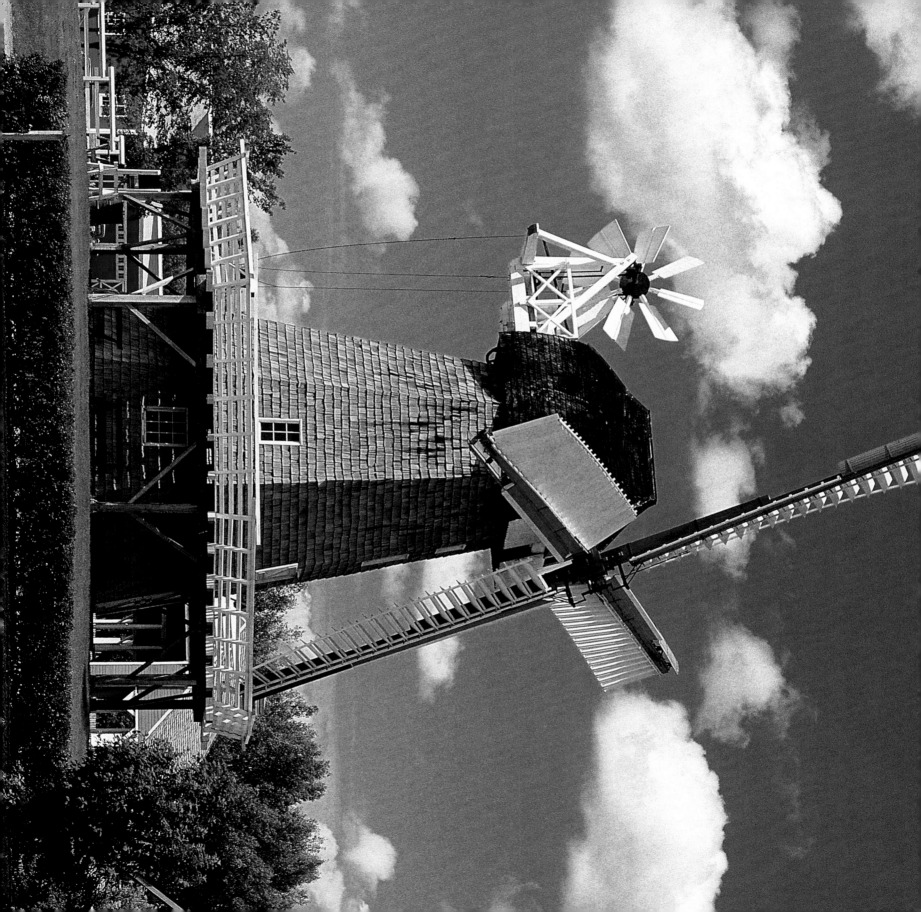

Manitoba's first Mennonite immigrants were fleeing persecution in Russia. They settled in the province after the government promised them religious freedom and exemption from military service.

At Mennonite Heritage Village, visitors discover the culture of Mennonites who settled the Steinbach area in 1874. The village includes farm buildings, houses, a traditional church, and a distinctive shingled windmill.

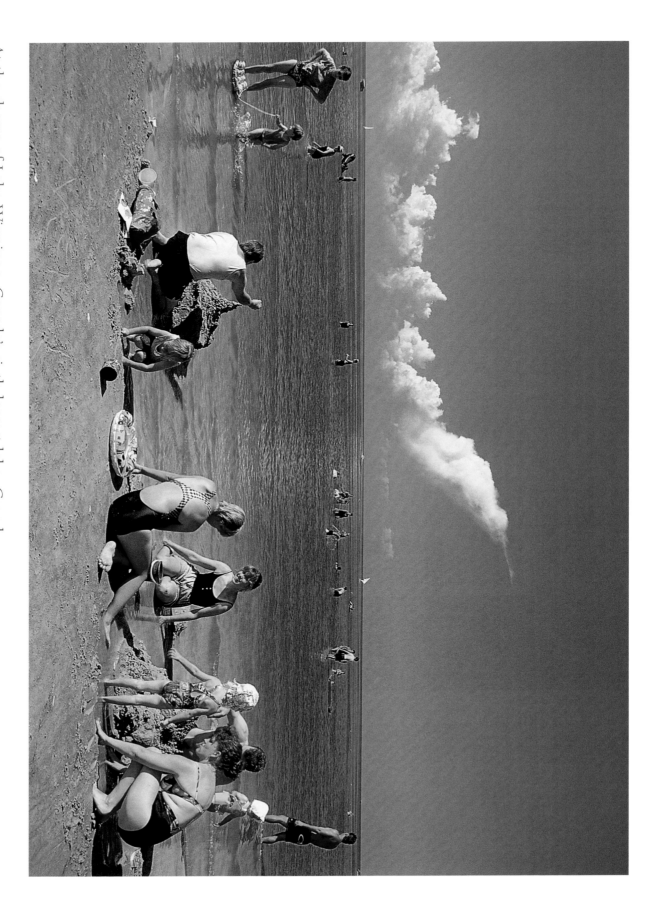

At the shores of Lake Winnipeg, Canada's sixth-largest lake, Grand Beach offers rolling dunes and long stretches of white sand beach. The area draws thousands of sunseekers each summer.

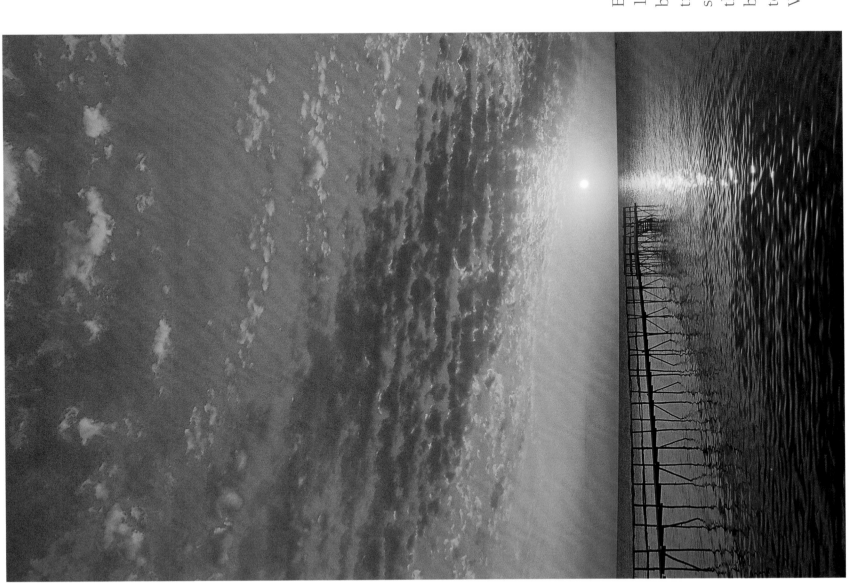

Even in the early 1900s, city dwellers boarded passenger trains to visit the sunny beaches of the Interlake region, between Lake Manitoba and Lake Winnipeg.

71

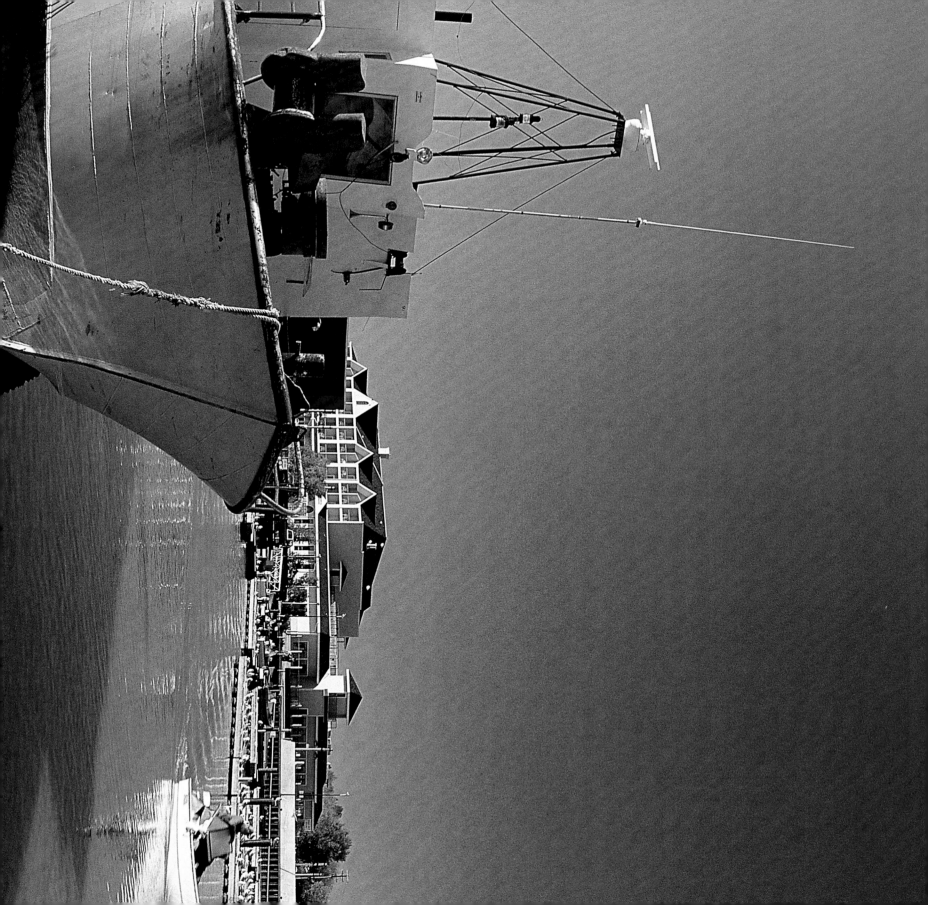

Hecla Island, part of Hecla/Grindstone Provincial Park, was named after volcanic Mount Hekla in Iceland. Until 1897, the islands that now form the park were part of an independent Icelandic settlement.

One might not expect commercial fisheries to thrive in Manitoba, but fleets such as this one in Gimli contribute more than $30 million each year to the provincial economy, with catches of walleye, whitefish, and other freshwater species.

The Viking statue in Gimli pays tribute to the heritage of Icelandic Canadians. Driven from Iceland by economic hardship, they established the Republic of New Iceland on the shores of Lake Winnipeg.

74

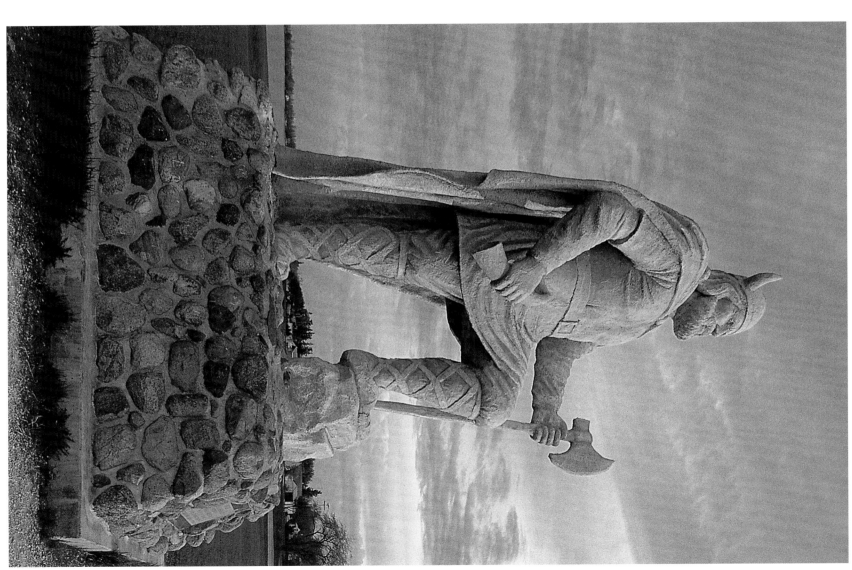

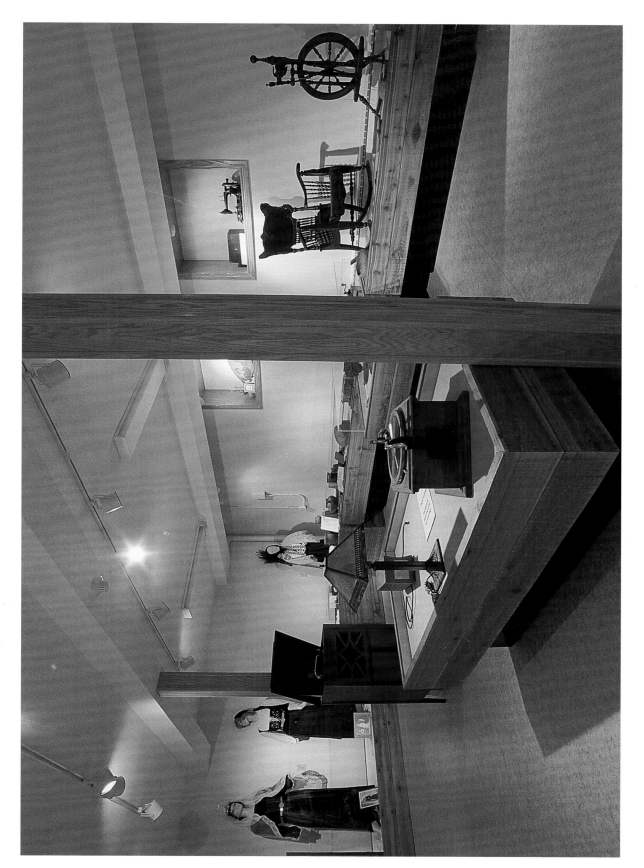

Gimli means "great hall of heaven" in the language of the area's first non-native immigrants. The town remains the largest Icelandic community outside of Iceland.

Setting Lake near Wabowden is one of 100,000 lakes in the province. Together, these bodies of water cover 16 percent of Manitoba.

A slight breeze stirs Little Limestone Lake. About 1.7 billion years ago, central Manitoba was a massive volcanic range. Erosion gradually wore the rock away, leaving the rocky plain we now know as the Canadian Shield.

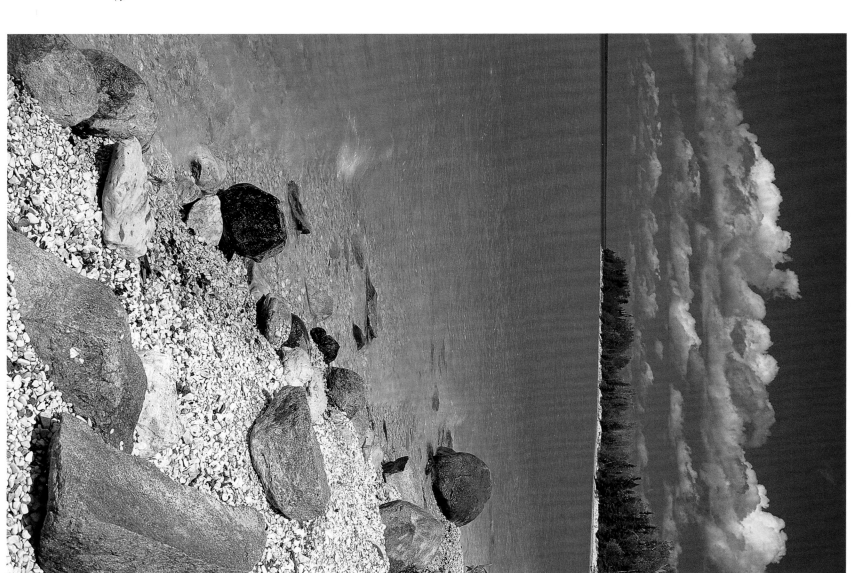

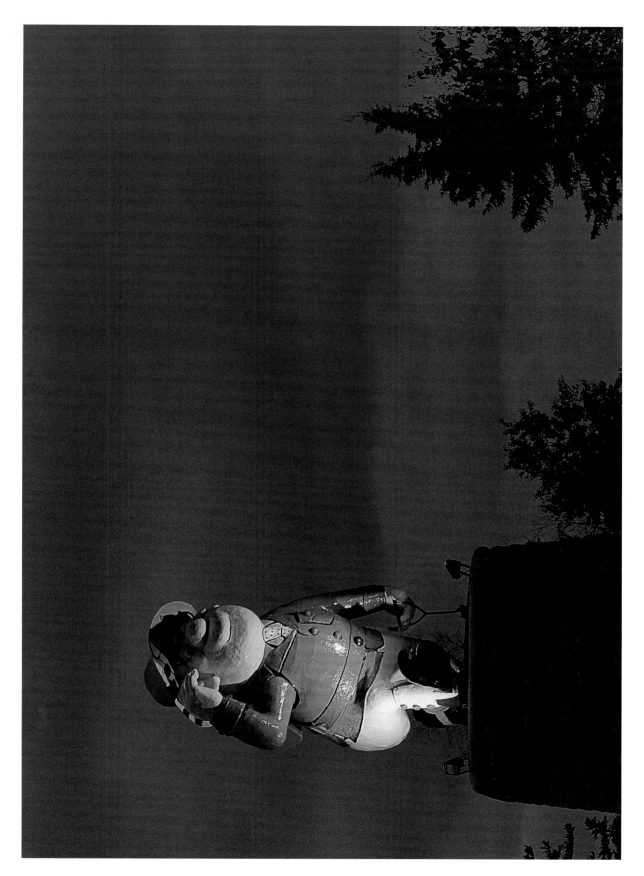

Early miners named Flin Flon after dime novel character Josiah Flintabbatey Flonatin. A statue of this personality, created by cartoonist Al Capp, graces the city entrance.

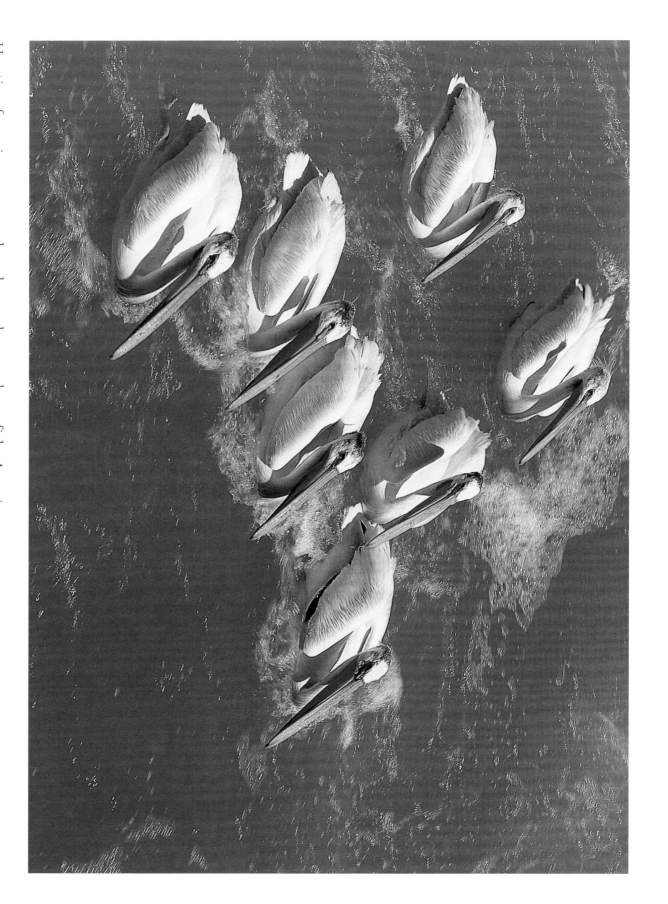

Hunting for minnows, perch, salamanders, and crayfish, American white pelicans spend their summers on the prairies. They winter in the southern United States, Mexico, and even as far as South America.

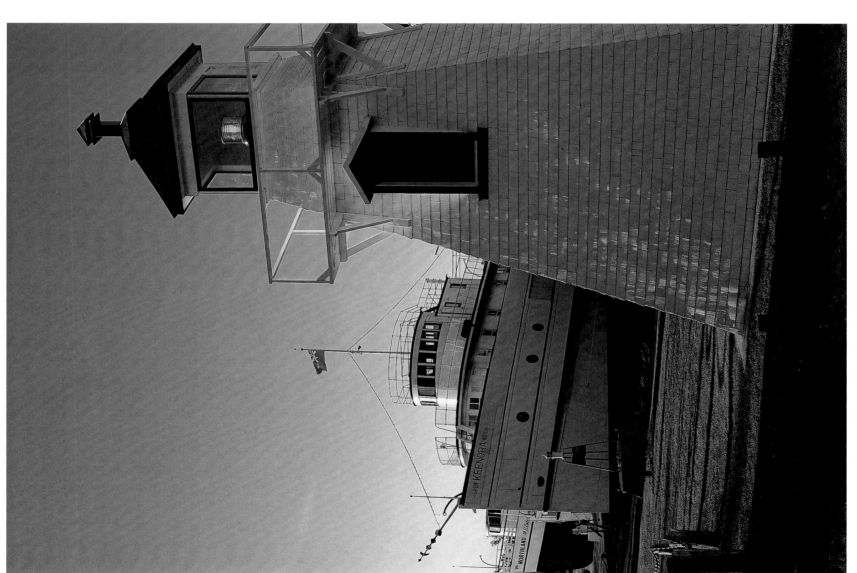

The Marine Museum in Selkirk celebrates Manitoba's nautical history. The five ships on display include a passenger steamship and an icebreaker.

The Grass River in northern Manitoba drops 13 metres (43 feet) at Pisew Falls, shooting through a narrow gorge at the bottom. This area was mapped by Hudson's Bay Company explorer Samuel Hearne, and the Grass River became a major route in the fur trade.

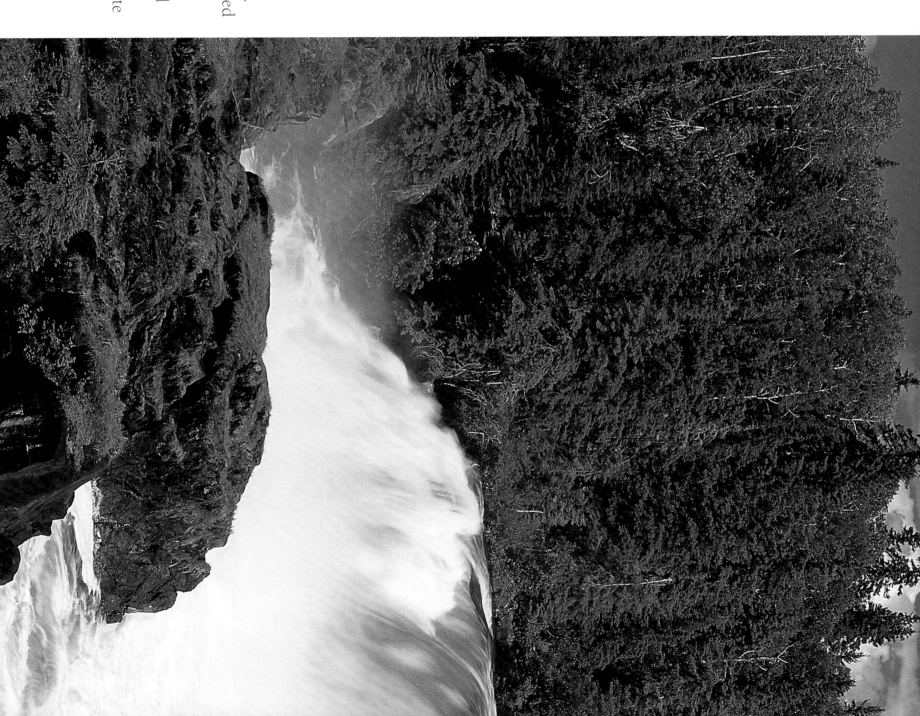

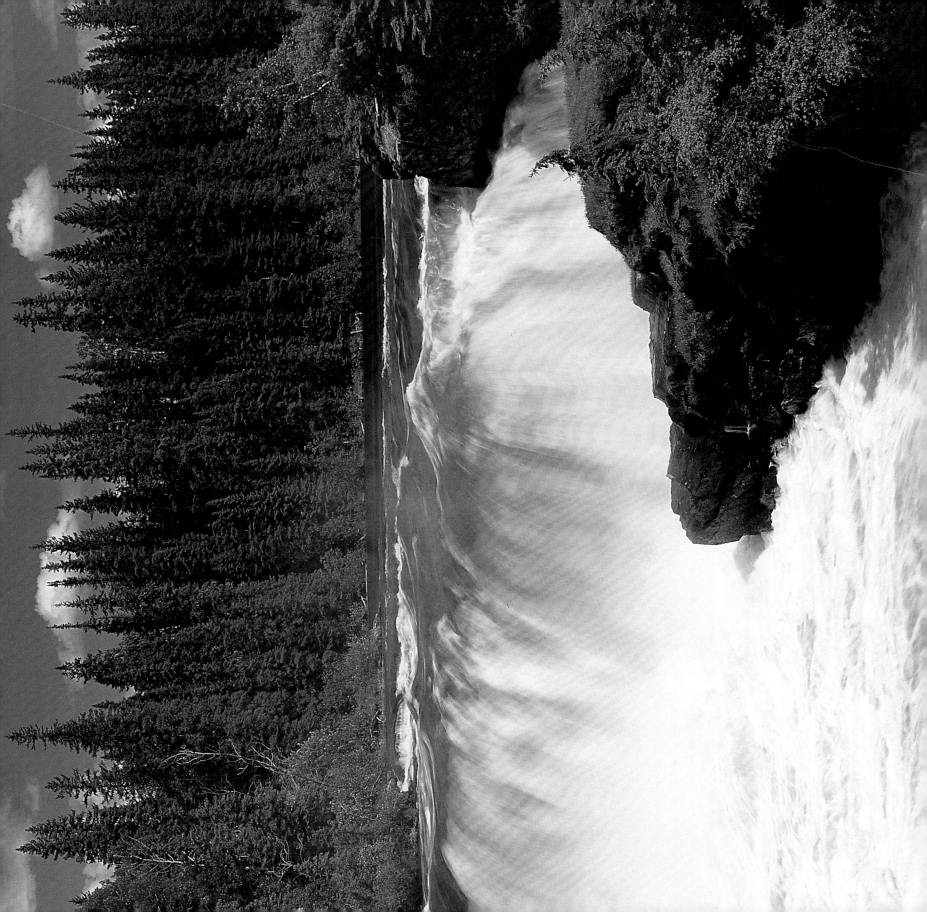

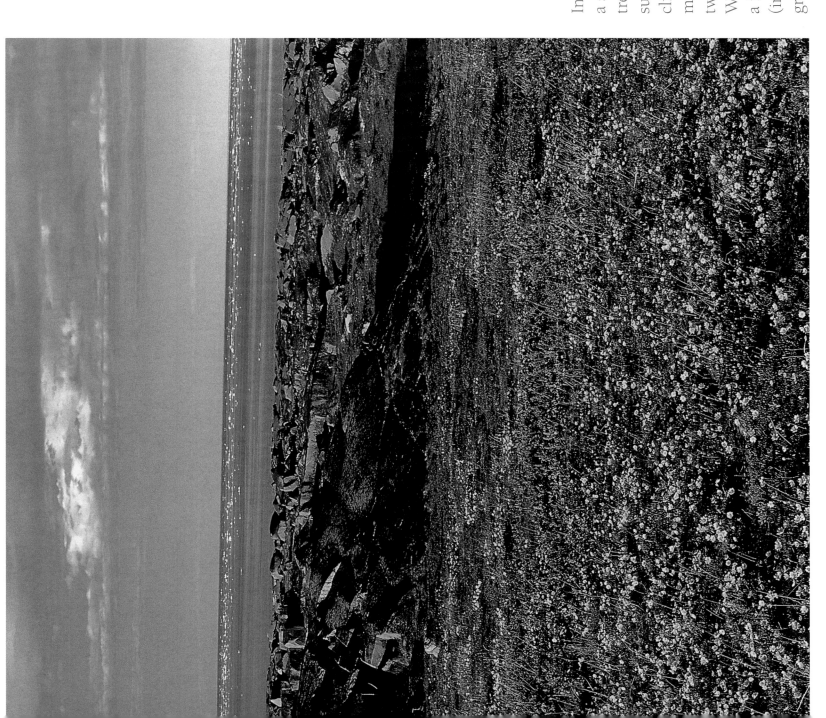

In a hundred years, a spruce or tamarack tree struggling to survive in the harsh climate of the tundra might grow only two metres (six feet). Willows reach only a few centimetres (inches) from the ground.

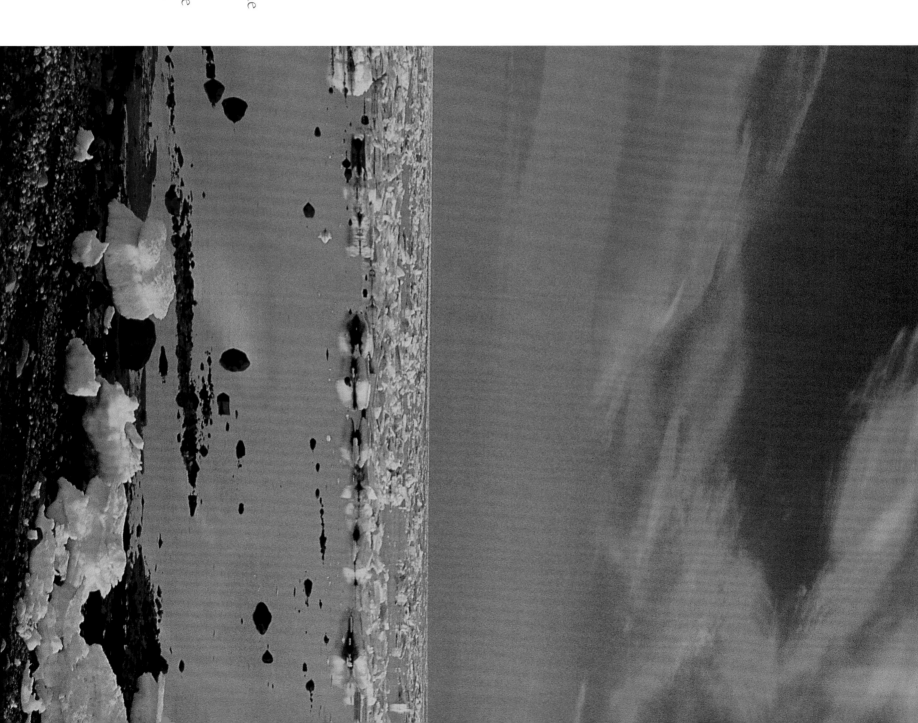

The land along
the 644-kilometre
(400-mile) coastline
of Hudson Bay is
locked in ice for
eight months of the
year. Even in sum-
mer, huge chunks
of ice float near
the shore.

86

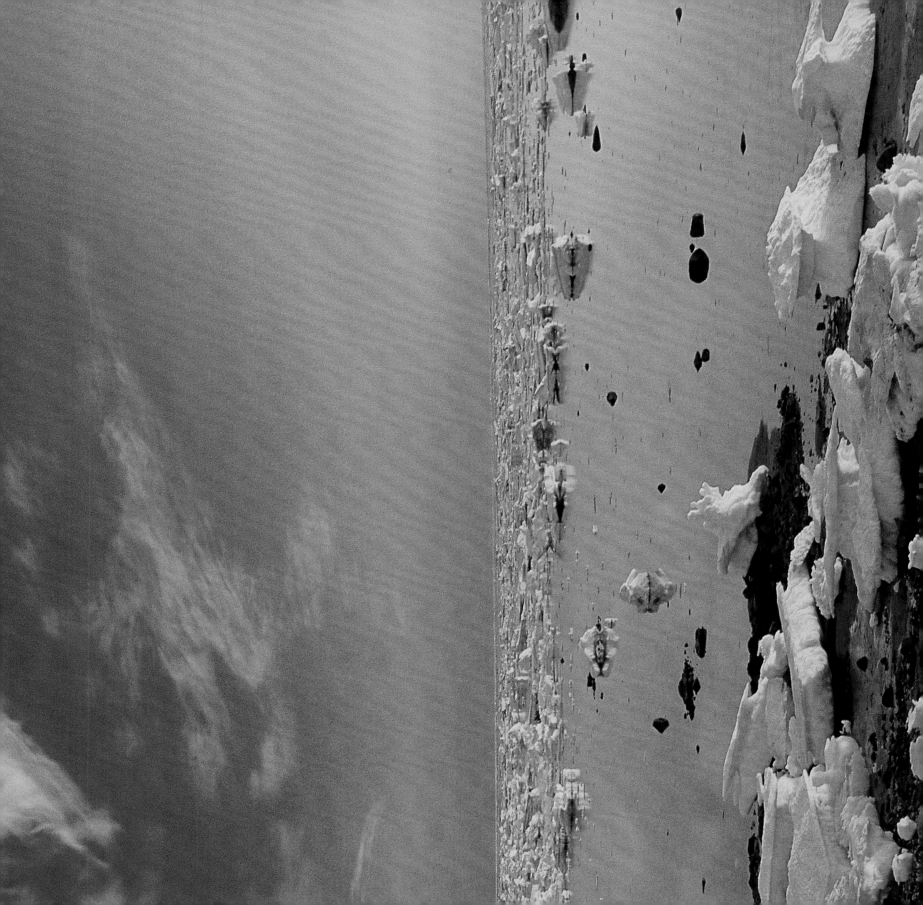

The walls of Prince of Wales's Fort, six metres (20 feet) high and 12 metres (39 feet) wide, were guarded by 40 cannons.

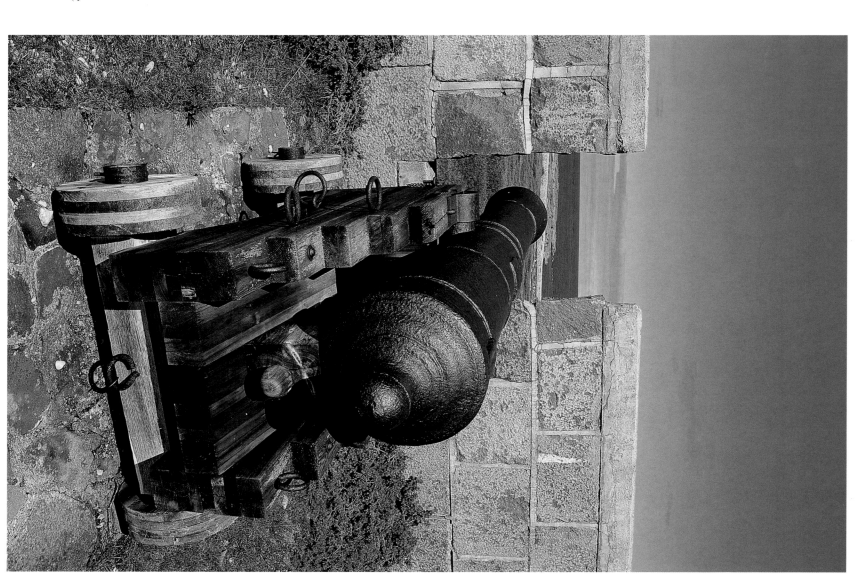

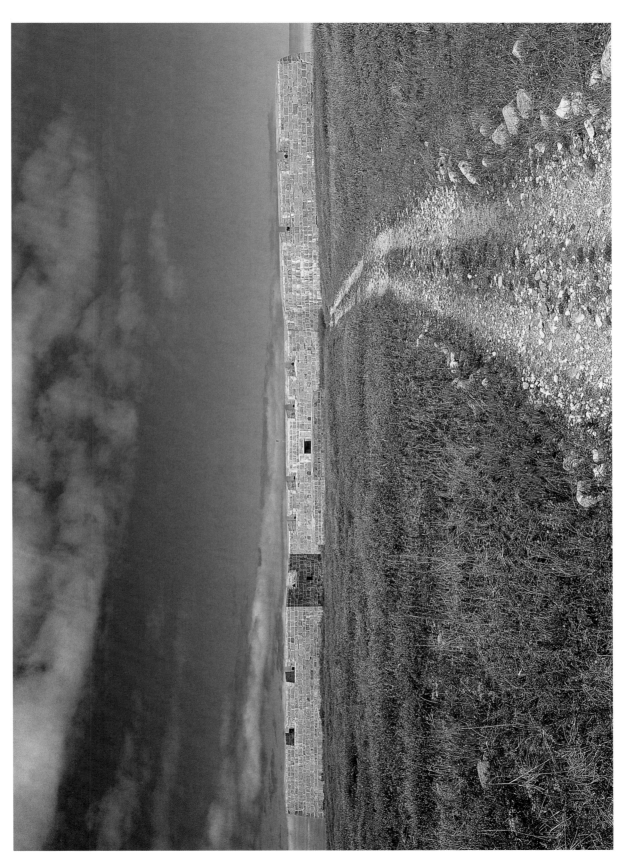

British forces built Prince of Wales's Fort at the mouth of the Churchill River between 1731 and 1771. Visitors to Churchill—site of the first Hudson's Bay Company outpost in the area—hike a five-kilometre (three-mile) trail to the remains of the fort.

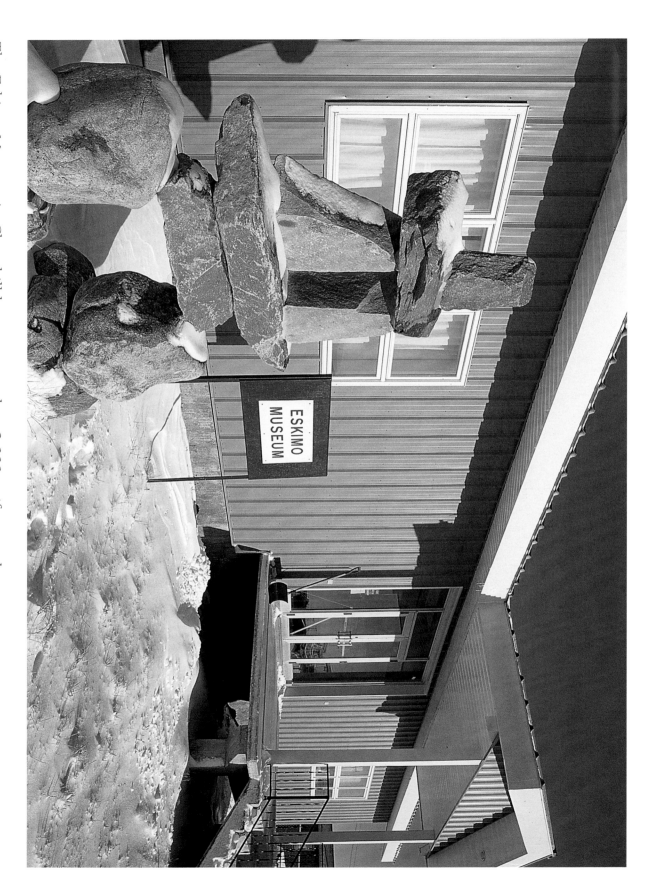

The Eskimo Museum in Churchill houses more than 3,000 artifacts and 800 works of art, tributes to the culture and history of the Inuit people. The stone sculpture, called an *inukshuk*, is traditionally built by the Inuit to serve as a landmark or in long rows to drive caribou toward waiting hunters.

ESKIMO MUSEUM

Paint Lake Provincial Recreation Park protects 24,290 hectares (60,000 acres) of the Canadian Shield. Playgrounds, a marina, a beach, camping facilities, and lakes with good fishing make this a favourite summer escape.

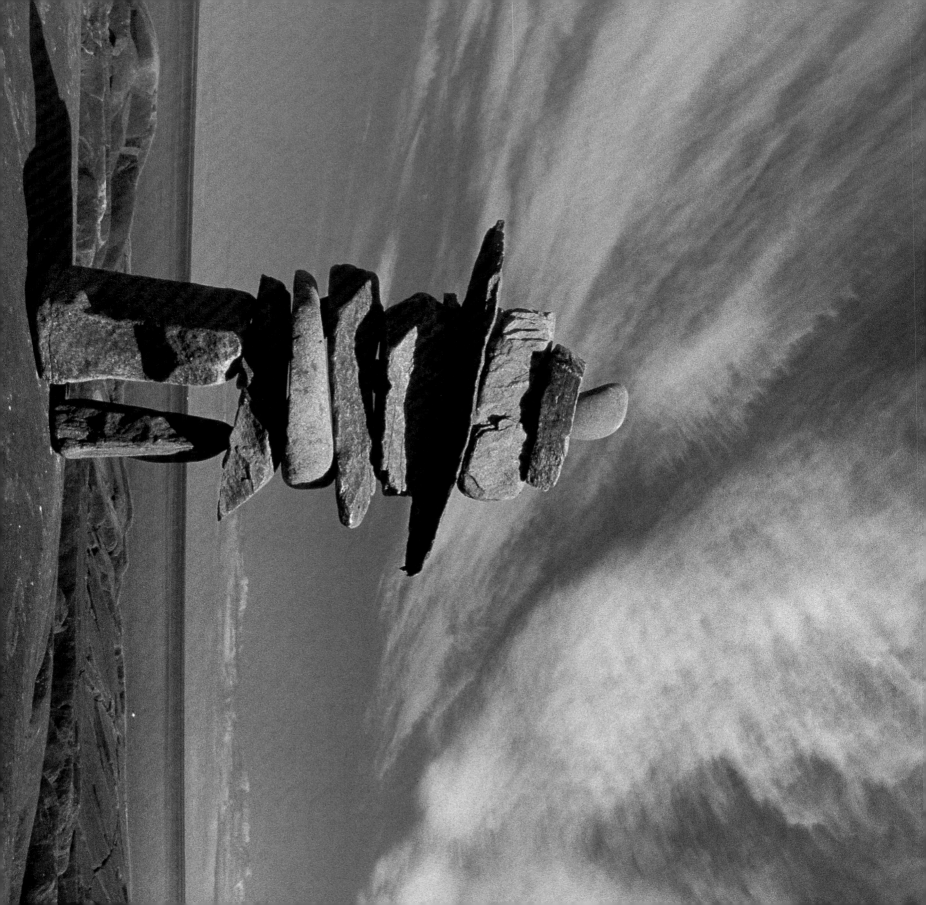

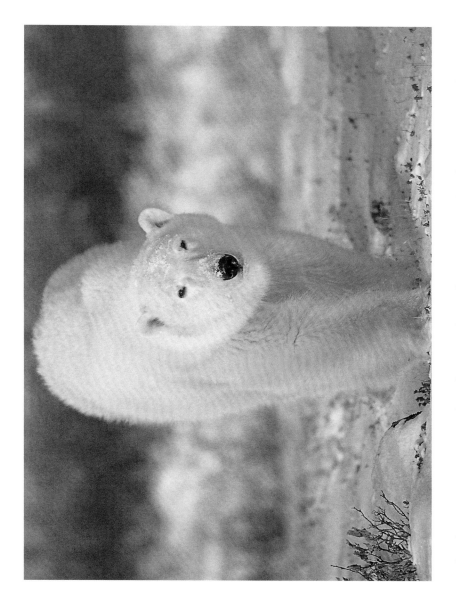

Polar bears migrate to the shores of Hudson Bay in the fall, waiting for the winter freeze and access to their hunting grounds on the pack ice. This is one of the only times these normally solitary creatures gather.

The first inhabitants arrived in Manitoba between 10,000 and 13,000 B.C., hunting in the plains of the southwest. The ancestors of the Inuit people are believed to have arrived on the shores of Hudson Bay in 1500 B.C.

Most common in spring and fall, the aurora borealis—northern lights—sweep across the sky in patterns of green, blue, rose, yellow, and crimson. The effects are caused when solar winds meet the earth's magnetic field above the north pole.